Letters of Note

Letters of Note was born in 2009 with the launch of lettersofnote.com, a website celebrating old-fashioned correspondence that has since been visited over 100 million times. The first *Letters of Note* volume was published in October 2013, followed later that year by the first Letters Live, an event at which world-class performers delivered remarkable letters to a live audience.

Since then, these two siblings have grown side by side, with *Letters of Note* becoming an international phenomenon, and Letters Live shows being staged at iconic venues around the world, from London's Royal Albert Hall to the theatre at the Ace Hotel in Los Angeles.

You can find out more at lettersofnote.com and letterslive.com. And now you can also listen to the audio editions of the new series of *Letters of Note*, read by an extraordinary cast drawn from the wealth of talent that regularly takes part in the acclaimed Letters Live shows.

Letters of Note

ART

COMPILED BY **SHAUN USHER**

CANONGATE

For Sarah

First published in Great Britain in 2020
by Canongate Books Ltd,
14 High Street, Edinburgh EH1 1TE

canongate.co.uk

1

For permission credits, please see p. 130

British Library Cataloguing-in-Publication Data
A catalogue record for this book is available on
request from the British Library

ISBN 978 1 83885 146 0

Typeset in Joanna MT 10.5/14 pt by
Palimpsest Book Production Ltd, Falkirk, Stirlingshire

Printed and bound in Great Britain by Clays Ltd, Elcograf S.p.A.

CONTENTS

INTRODUCTION ix

01 THE CANVAS HAS AN *IDIOTIC* STARE
Vincent van Gogh to Theo van Gogh 2

02 FUCK THE ART WORLD PRESSURES
Lucy R. Lippard to a Young Woman Artist 6

03 HOW BEAUTIFUL!
Salvador Dalí to Federico García Lorca 8

04 I AM NOT GOING TO STAND FOR IT
Oscar Howe to Jeanne Snodgrass King 11

05 IF I WERE A MAN, I CANNOT IMAGINE IT WOULD TURN OUT THIS WAY
Artemisia Gentileschi to Don Antonio Ruffo 14

06 WHY CAN'T WE PAINT LIKE THE ROMANTICS ANY MORE?
Carl Jung to Arnold Kübler 18

07 IT IS ALL FOR LOVE AND HONOR
Hollis Frampton to MoMA 22

08 ART IS A GREAT INTELLECTUAL STIMULUS
Mary Cassatt to Theodate Pope 32

09 A LANDSCAPE PAINTER'S DAY IS DELIGHTFUL
Jean-Baptiste-Camille Corot to an unknown recipient 36

10 AN ARTIST MUST POSESS NATURE
Henri Matisse to Henry Clifford 39

11 LET ME HAVE ARTISTS FOR FRIENDS
J.D. Fergusson to Margaret Morris 44

12 AN OBJECT OF PECULIAR ODIUM
Harriet Hosmer to *Art-Journal* 48

13 GRAFFITI LOOKS LIKE SHIT
Michael Grady to Alicia McCarthy 52

14 POP ART IS:
Richard Hamilton to Peter and Alison Smithson 56

15 DIVERSITY GUARANTEES OUR CULTURAL SURVIVAL
Martin Scorsese to the *New York Times* 60

16 IS THIS TOO MUCH TO ASK OF WHITE AMERICAN CHIVALRY?
Augusta Savage to the *New York World* newspaper 64

17 ART IS AN ADVENTURE INTO AN UNKNOWN WORLD
Mark Rothko and Adolph Gottlieb to the *New York Times* 68

18 THE MOST SPECTACULAR MONOCHROME REALIZATIONS
Yves Klein to the President of the International Conference for the Detection of Nuclear Explosions 74

19 IF IT IS NOT THOUGHT OUT, IT IS NOTHING
Oscar Wilde to Marie Prescott 78

20 DEAR EDITOR
Adrian Piper to various editors 82

21 PAINTING AND SCULPTURE ARE ONE AND THE SAME THING
Michelangelo to Benedetto Varchi 91

22 THE POINT OF BEING AN ARTIST IS THAT YOU MAY LIVE
Sherwood Anderson to John Anderson 94

23 WHAT LIMBS THAT MAN COULD DRAW!
Paula Modersohn-Becker to Carl Woldemar Becker 98

24 SPECIFICALLY, A DUEL
Mark Pauline to Dennis Oppenheim 102

25 I AM NO LONGER AN ARTIST
Paul Nash to Margaret Nash 105

26 AN EXPLOSIVE SLAB OF CHOCOLATE
Lord Victor Rothschild to Laurence Fish 108

27 TO HELL WITH THE EXHIBITION
Frida Kahlo to Nickolas Muray 112

28 I AM NOT MAURITS TO HIM
Mick Jagger and M. C. Escher 118

29 I AM APPALLED BY MOCA'S DECISION
Hans Haacke to Richard Koshalek 121

30 DO
Sol LeWitt to Eva Hesse 125

PERMISSION CREDITS 130

ACKNOWLEDGEMENTS 132

A letter is a time bomb, a message in a bottle, a spell, a cry for help, a story, an expression of concern, a ladle of love, a way to connect through words. This simple and brilliantly democratic art form remains a potent means of communication and, regardless of whatever technological revolution we are in the middle of, the letter lives and, like literature, it always will.

INTRODUCTION

Think of this book as a gallery.

Better still, a private gallery that fits in your
pocket, with no rules to speak of. *Yes*, you can touch
the exhibits. Of *course* you can take photos with the
flash on. And *no*, you are *not* required to speak
quietly. On the walls of this gallery can be found
thirty letters of note, all of which in some way
shine a light on various moments in the history of
art and illuminate them for your enjoyment; most,
but not all, written through the ages by artists
themselves – artists who momentarily put down
their pencils, their paintbrushes, their chisels, and
instead put pen to paper to create the windows into
the art world through which you are soon to look.

Like art so often can, some of these letters act as
portals to a particular time and place. Just as
Constable's *The Hay Wain* immediately transports you
to the River Stour beneath a cluster of clouds one
calm day in the nineteenth century, so too shall war
artist Paul Nash's bleakly harrowing missive to his
wife drop you onto the hellish field of battle
during World War I; and just as the broad, expres-
sive brushstrokes of Rembrandt's *Self-Portrait*

somehow reveal so much about someone you have never met, so too will Italian painter Artemisia Gentileschi's defiant letter to her patron, written at a time when she was simply not meant to succeed, paint a powerful picture of its determined author.

Additionally, just hearing the voice of an artist through their letters can be an odd and thrilling experience. I can vividly remember the time I was introduced to the correspondence of Salvador Dalí, whose otherworldly paintings defy description – his fantastical landscapes littered with scenes that play tricks on the mind, causing the viewing experience to become almost hallucinatory. Not for one moment did I imagine that his letters would provoke a similar reaction in me. Yet here was I, letter in hand, baffled and amused in equal measure by his seemingly random talk of 'stray breasts' and 'nests of anaesthetized wasps', but delighted to hear his voice loud and clear in a different medium – strangely comforted to feel his art pushing through the page.

Letters offer an artist a different creative outlet, and a means by which to discuss the final product they thrust out into the world. To be able to read about their process, their fears, their excitement, is an opportunity too valuable to ignore.

Having spent a considerable portion of my adult

life obsessively sifting through the correspondence of others in search of the latest masterpiece, I am firmly of the belief that *some* letters can and should themselves be considered works of art – invaluable, often culturally significant objects to be enjoyed and appreciated by as wide an audience as possible. Which is why, hanging on the wall to my left as I write, is a framed copy of Sol LeWitt's incomparable letter of encouragement to fellow artist Eva Hesse, a piece of correspondence so impactful, thought-provoking and creatively stimulating that it also happens to close the book you now hold, each of its 800 words working as hard as the individual brushstrokes of any oil painting.

Perhaps, when you leave this tiny gallery, you may be inclined to fill a space on a wall of your own.

Shaun Usher
2020

The Letters

LETTER 01
THE CANVAS HAS AN *IDIOTIC* STARE

Vincent van Gogh to Theo van Gogh
2 October 1884

It wasn't until his thirties that Dutch painter Vincent van Gogh found his calling as an artist. Born in Zundert in 1853, his early years saw him flit from job to job, his only real focus being a deepening dedication to religion. In 1879 he took a missionary post in Belgium where he lived in poverty and squalor. His family, who had supported him for years, were losing patience; at one point his father even tried to have him committed to an asylum. In 1881, with financial backing from his younger brother, Theo, Vincent began to paint, and for the remainder of his life spent much of his time creating the work for which he is now known. In 1884, aged thirty-one, he wrote this letter to his brother. It would be six years later, in Auvers-sur-Oise, that Vincent, deeply depressed, would take his own life.

THE LETTER

My dear Theo,
Thanks for your letter, thanks for the enclosure.
Now listen here.

. . .

I tell you, if one wants to be active, one mustn't be afraid to do something wrong sometimes, not afraid to lapse into some mistakes. To be good – many people think that they'll achieve it by *doing no harm* – and that's a lie, and you said yourself in the past that it was a lie. That leads to stagnation, to mediocrity. *Just slap something on* it when you see a blank canvas staring at you with a sort of imbecility.

You don't know how *paralyzing* it is, that *stare* from a blank canvas that says to the painter *you can't do anything*. The canvas has an *idiotic* stare, and mesmerizes some painters so that they turn into idiots themselves. Many painters *are afraid* of the blank *canvas*, but the blank canvas IS AFRAID of the truly passionate painter who dares – and who has once broken the spell of 'you can't'.

Life itself likewise always turns towards one an infinitely *meaningless*, discouraging, dispiriting blank

side on which there is *nothing*, any more than on a blank canvas.

But *however* meaningless and vain, however dead life appears, the man of faith, of energy, of warmth, and who knows something, doesn't let himself be fobbed off like that. He steps in and does something, and hangs on to that, in short, breaks, 'violates' – they say.

Let them talk, those cold theologians

'SUCCESS IS SCIENCE;
IF YOU HAVE THE
CONDITIONS, YOU GET
THE RESULT.'

— *Oscar Wilde*

FUCK THE ART WORLD PRESSURES
Lucy R. Lippard to a Young Woman Artist
1974

In 1974 Miriam Schapiro, co-founder and director of the Feminist Art Program at the California Institute of the Arts, encouraged seventeen of her female students to write to women in the art world with a request: to reply with a letter of advice to a 'Young Woman Artist'. These invaluable pieces of correspondence were then to be compiled in Anonymous Was a Woman, *a book to be published as part of that year's Women's Art Festival. Before long, letters arrived from seventy-one of the women, including Lucy R. Lippard, a highly respected and influential writer, curator, art critic and feminist whose achievements are rivalled by very few.*

THE LETTER

March 6, 1974
138 Prince St.
NYC 10012

To a Young Woman Artist,
I'm sorry this has to be so short, because I have a
lot I'd like to talk about with you, but try to read
between the lines. I hope you're angry but get it
over with fast and use it while you've got it. I hope
you don't stop being angry now and then until
things are better for all women, not just artists; I
hope you're working from yourself and know how
to fuck the art world pressures when you get out
there; and I hope you're working for everybody else
too; I hope you'll be the one to figure out a way to
keep art from being used the wrong way and for the
wrong things in this society; I hope you make your
art accessible to more people, to all women and to
everybody; I hope you think about that now and
aren't waiting till you make it, because that's likely
to be too late. I hope you remember that being a
feminist carries with it a real responsibility to be a
human. I hope and I hope and I hope . . .

love,
Lucy Lippard

LETTER 03
HOW BEAUTIFUL!

Salvador Dalí to Federico García Lorca

December 1927

Born in Catalonia in 1904, Salvador Dalí's artworks are known the world over thanks in no small part to their surreal, dreamlike nature. His iconic paintings are filled with optical illusions, distorted scenery, melting objects and sexual imagery. This, coupled with a flamboyant persona that itself was somewhat a work of art, have cemented his place in the annals of art history. At college in 1923, Dalí met and grew close to the poet Federico García Lorca, and for some time they wrote to each other on a whole host of subjects. It is no surprise to learn that Dalí's letters are like nothing written before.

THE LETTER

Federico,

I'm working on paintings that make me die for joy,
I'm creating in a purely natural way, without the
slightest artistic worry, and finding things that
move me deeply, and trying to paint honestly, that
is, *exactly*. In that sense I'm beginning to completely
understand the senses. Sometimes I think I've
recovered – with unsuspected intensity – the "illu-
sions" and joys of my childhood. I feel a great love
for grass, thorns in the palm of the hand, ears red
against the sun, and the little feathers of bottles.
Not only does all this delight me, but also the
grapevines and the donkeys that crowd the sky.

Just now I'm painting a very beautiful smiling
woman, *bristling* with *feathers of every color*, held up by
a small marble dice that is *on fire*. The marble dice is
supported, in turn, on a quiet, humble little plume
of smoke. In the sky are donkeys with parrot heads,
grass and sand from the beach, all about to
explode, all clean, incredibly objective, and the
scene is awash in an indescribable blue, the green,
the red and yellow of a parrot, an edible white, the
metallic white of a stray breast (you know that
there are also "stray breasts," just the opposite of
the flying breast, for the stray one is at peace

without knowing what to do and is so defenseless it moves me).

Stray breasts (how beautiful!)

After this, I'm thinking of painting a nightingale. It will be titled NIGHTINGALE and it will be a feathered vegetal donkey in the woodsy canopy of a sky bristling with nettles, etc. etc.

Helle, dear sir! Yessirree, you must be rich. If I were with you I would be your whore to cajole you and steal peseta notes to dip in donkey piss . . .

I'm tempted to send you a piece of my lobster-colored pajamas, or better yet,
"lobster-dream-colored" pajamas, to see if you are moved, in your opulence, to send me money [. . .] Anyway, just think, with a little money, with 500 pesetas, we could bring out an issue of the ANTI-ARTISTIC magazine and shit on everyone and everything from the Orfeo Catalán to Juan Ramón.

(Give Margarita a kiss on the tip of her nose, the whole thing is like a nest of anaesthetized wasps.)

Farewell, Sir, a kiss on
the palmtree from your
ROTTING DONKEY

LETTER 04
I AM NOT GOING TO STAND FOR IT
Oscar Howe to Jeanne Snodgrass
18 April 1958

Oscar Howe was born in 1915 on the Crow Creek Sioux
Reservation in South Dakota, a direct descendant of
Yankton Sioux Chiefs. As a child he attended Pierre
Indian School, then studied art under Dorothy Dunn at
Santa Fe Indian School, and eventually obtained a
Master of Fine Arts at the University of Oklahoma, all
while building a solid reputation for his modernist
depictions of Native American life. In 1958 he
submitted one of his abstract works, Umine Wacipe:
War and Peace Dance, *for an annual exhibition of*
Indian art at the Philbrook Art Center in Tulsa,
Oklahoma, only for it to be rejected for supposedly not
being a 'traditional Indian painting'. Howe responded
with a letter that eventually led to change and accept-
ance both at the institution and in the wider art
community; it was written to Jeanne Snodgrass King,
the museum's curator of Native American art.

THE LETTER

Dear Mrs Snodgrass,

Who ever said that my paintings are not in the
traditional Indian style has poor knowledge of
Indian art indeed. There is much more to Indian
Art than pretty, stylized pictures. There was also
power and strength and individualism (emotional
and intellectual insight) in the old Indian paintings.
Every bit in my painting is a true, studied fact of
Indian paintings. Are we to be held back forever
with one phase of Indian painting, with no right
for individualism, dictated to as the Indian has
always been, put on reservations and treated like a
child, and only the White Man knows what is best
for him? Now, even in Art, "You little child do
what we think is best for you, nothing different."
Well, I am not going to stand for it. Indian Art can
compete with any Art in the world, but not as a
suppressed Art. I see so much of the mismanage-
ment and treatment of my people. It makes me cry
inside to look at these poor people. My father died
there about three years ago in a little shack, my
two brothers still living there in shacks, never
enough to eat, never enough clothing, treated as
second class citizens. This is one of the reasons I
have tried to keep the fine ways and culture of my

forefathers alive. But one could easily turn to become a social protest painter. I only hope the Art World will not be one more contributor to holding us in chains.

Oscar Howe

LETTER 05
IF I WERE A MAN, I CANNOT IMAGINE IT WOULD TURN OUT THIS WAY
Artemisia Gentileschi to Don Antonio Ruffo
13 November 1649

Born in 1593 to Prudenzia di Ottovania Montoni and her husband, Orazio Gentileschi, an acclaimed Tuscan painter, Artemisia Gentileschi was twelve years old when her mother died; she was then brought up and tutored in painting by her father, whose artistic talents she eventually surpassed. When she was seventeen, Artemisia was raped by her tutor, Agostino Tassi. At the trial, to assess the truthfulness of her testimony, she was tortured with thumbscrews and subsequently believed. Despite this, she went on to become one of the most acclaimed artists of seventeenth-century Europe, a Baroque painter of immense talent whose work is notable for its depictions of strong, heroic women. One of her most famous oil paintings, Judith Slaying Holofernes, *shows a biblical scene in which an Assyrian general is beheaded by Old Testament heroine Judith, with help from a maid; another piece, titled* Jael and Sisera, *shows a different woman poised to hammer a peg into the head of a defeated general. This letter, written to her patron in 1649, shows Artemisia pushing back against unreasonable demands from a potential male client.*

THE LETTER

My Most Illustrious Sir,

I have received a letter of October 26th, which I
deeply appreciated, particularly noting how my
master always concerns himself with favoring me,
contrary to my merit. In it, you tell me about that
gentleman who wishes to have some paintings by
me, that he would like a Galatea and a Judgment of
Paris, and that the Galatea should be different from
the one that Your Most Illustrious Lordship owns.
There was no need for you to urge me to do this,
since by the grace of God and the Most Holy
Virgin, they [clients] come to a woman with this
kind of talent, that is, to vary the subjects in my
painting; never has anyone found in my pictures
any repetition of invention, not even of one hand.

As for the fact that this gentleman wishes to
know the price before the work is done . . . I do it
most unwillingly . . . I never quote a price for my
works until they are done. However, since Your
Most Illustrious Lordship wants me to do this, I
will do what you command. Tell this gentleman
that I want five hundred ducats for both; he can
show them to the whole world and, should he find
anyone who does not think the paintings are worth
two hundred scudi more, I won't ask him to pay

me the agreed price. I assure Your Most Illustrious Lordship that these are paintings with nude figures requiring very expensive female models, which is a big headache. When I find good ones they fleece me, and at other times, one must suffer [their] pettiness with the patience of Job.

As for my doing a drawing and sending it, I have made a solemn vow never to send my drawings because people have cheated me. In particular, just today I found . . . that, having done a drawing of souls in Purgatory for the Bishop of St. Gata, he, in order to spend less, commissioned another painter to do the painting using my work. If I were a man, I can't imagine it would have turned out this way . . .

I must caution Your Most Illustrious Lordship that when I ask a price, I don't follow the custom in Naples, where they ask thirty and then give it for four. I am Roman, and therefore I shall act always in the Roman manner.

From Naples, the 13th of November, 1649.

The most humble servant of Your Most Illustrious Lordship,

Artemisia Gentileschi

'IF I WERE A MAN, I
CAN'T IMAGINE IT
WOULD HAVE TURNED
OUT THIS WAY . . .'

— *Artemisia Gentileschi*

LETTER 06
WHY CAN'T WE PAINT LIKE THE
ROMANTICS ANY MORE?
Carl Jung to Arnold Kübler
10 April 1942

Although known to most for his work in the field of psychoanalysis, not least as the founder of analytical psychology, Swiss psychiatrist Carl Jung was a keen and talented artist, having practised privately from a young age. Between 1914 and 1930 he created The Red Book, *a giant, beautifully illustrated volume in which he recorded and analysed an intense period of self-reflection; it was seen by few people while he was alive, but has since been published. He also believed the practice of art to be an effective form of therapy. In 1942, amidst the horrors of World War II, he was asked by Swiss author Arnold Kübler: 'Why can't we paint like the Romantics any more?'. This letter contained his answer.*

THE LETTER

10 April 1942

Dear Herr Kübler,

I have been mulling over your question about the
Romantics but have come to the conclusion that,
fully occupied as I am with my own work at
present, I could hardly muster the necessary
patience to expatiate on such a contemplative
theme as "Why Can't We Paint Like the Romantics
Any More?" with the contemplativeness this
requires.

For that is what we lack at the present time –
contemplativeness.

If one is sitting on a volcano and can be
contemplative to boot, this is a superhuman
heroism which is itself a contradiction in terms.

Nowadays it's no longer any use appealing to
any certainties.

Deep down we know that everything is tottering.

When the earth quakes, there are only abrupt
and disjointed fragments, but no closely woven and
harmonious flower carpet.

A Romantic ideal in our time would be like a
figment from a feverish dream.

Therefore it is much better for modern art to

paint the thousand-hued debris of the shattered crockery than to try to spread a deceptive quietness over the bottomless disquiet.

The grotesque, the ugly, the distorted, the revolting perfectly fit our time, and if a new certainty does not start up somewhere, art will continue to express disquiet and inhumanity.

That is all I have to say on this question. It is abrupt and disjointed, like what we are talking about.

Yours truly,

C.G. Jung

'A ROMANTIC IDEAL IN
OUR TIME WOULD BE A
FIGMENT FROM A
FEVERISH DREAM.'

— C.G. Jung

LETTER 07
IT IS ALL FOR LOVE AND HONOR
Hollis Frampton to MoMA
7 January 1973

In December 1972 Donald Richie, then film curator at the Museum of Modern Art in New York, wrote to artist Hollis Frampton and suggested that they organise a retrospective of his work at this most prestigious of museums. To an artist of any standing, this would be a tempting offer; however, Frampton took issue with one particular line in the proposal, a single detail of Richie's which rendered the suggestion entirely unattractive: 'It is all for love and honor and no money is included at all . . .' Unwilling to work without financial reward, Frampton responded at length with a rousing letter that has since become legendary in the art world for reasons which are plain to see. It's fair to assume that a fee was later agreed: MoMA's Hollis Frampton retrospective ran from 8 to 12 March 1973.

THE LETTER

<div align="right">Box 99

Eaton, New York <u>13334</u>

January 7, 1973</div>

Mr Donald Richie
Curator of Film
The Museum of Modern Art
11 West 53 Street
New York, New York <u>10019</u>

Dear Donald:

I have your letter of December 13, 1972, in which
you offer me the honor of a complete retrospective
during this coming March. Let me stipulate at the
outset that I am agreed "in principle", and more:
that I appreciate very deeply being included in the
company you mention. I am touched to notice that
the dates you propose fall squarely across my
thirty-seventh birthday. And I am flattered by your
proposal to write notes.

But, having said this much, I must go on to
point out some difficulties to you.

To begin with, let me put it to you squarely that
<u>anyone</u>, institution or individual, is free at any time

to arrange a complete retrospective of my work; and that is not something that requires my consent, or even my prior knowledge. You must know, as well as I do, that all my work is distributed through the Film-Makers' Cooperative, and that it is available for rental by any party willing to assume, in good faith, ordinary responsibility for the prints, together with the price of hiring them.

So that something other than a wish to show my work must be at issue in your writing to me. And you open your second paragraph with a concise guide to what that 'something' is, when you say: "It is all for love and honor and no money is included at all . . .".

All right. Let's start with love, where we all started. I have devoted, at the nominal least, a decade of the only life I may reasonably expect to have, to making films. I have given to this work the best energy of my consciousness. In order to continue in it, I have accepted . . . as most artists accept (and with the same gladness) . . . a standard of living that most other American working people hold in automatic contempt: that is, I have committed my entire worldly resources, whatever they may amount to, to my art.

Of course, those resources are not unlimited. But the irreducible point is that I have made the

work, have commissioned it of myself, under no obligation of any sort to please anyone, adhering to my own best understanding of the classic canons of my art. Does that not demonstrate love? And if it does not, then how much more am I obliged to do? And who (among the living) is to exact that of me?

Now, about honor: I have said that I am mindful, and appreciative, of the honor to myself. But what about the honor of my art? I venture to suggest that a time may come when the whole history of art will become no more than a footnote to the history of film . . . or of whatever evolves from film. Already, in less than a century, film has produced great monuments of passionate intelligence. If we say that we honor such a nascent tradition, then we affirm our wish that it will continue.

But it <u>cannot</u> continue on love and honor alone. And this brings me to your: ". . . no money is included at all . . .".

I'll put it to you as a problem in fairness. I have made let us say, so and so many films. That means that so and so many thousands of feet of rawstock have been expended, for which I <u>paid</u> the manufacturer. The processing lab was <u>paid</u>, by me, to develop the stuff, after it was exposed in a camera

for which I <u>paid</u>. The lens grinders got <u>paid</u>. Then I edited the footage, on rewinds and a splicer for which I <u>paid</u>, incorporating leader and glue for which I also <u>paid</u>. The printing lab and the track lab were <u>paid</u> for their materials and services. You yourself, however meagerly, are being <u>paid</u> for trying to persuade me to show my work, to a paying public, for "love and honor". If it comes off, the projectionist will get <u>paid</u>. The guard at the door will be <u>paid</u>. Somebody or other <u>paid</u> for the paper on which your letter to me was written, and for the postage to forward it.

That means that I, in my singular person, by making this work, have already generated wealth for scores of people. Multiply that by as many other working artists as you can think of. Ask yourself whether my lab, for instance, would print my work for "love and honor": if I asked them and they took my question seriously, I should expect to have it explained to me, ever so gently, that human beings expect compensation for their work. The reason is simply that it enables them to continue doing what they do.

But it seems that, while all these others are to be paid for their part in a show that could not have taken place without me, nonetheless, I, the artist, am <u>not</u> to be paid.

And in fact it seems that there is no way to pay an artist for his work as an artist. I have taught, lectured, written, worked as a technician . . . and for all those collateral activities, I have been paid, I have been compensated for my work. But as an artist I have been paid only on the rarest of occasions.

I will offer you further information in the matter:

Item: that we filmmakers are a little in touch with one another, or that there is a "grapevine", at least, such as did not obtain two and three decades ago, when The Museum of Modern Art (a different crew then, of course) divided filmmakers against themselves, and got not only screenings, but "rights" of one kind and another, for nothing, from the generation of Maya Deren.

Well Maya Deren, for one, died young, in circumstances of genuine need. I leave it to your surmise whether her life might have been prolonged by a few bucks. A little money certainly would have helped with her work: I still recall with sadness the little posters, begging for money to help her finish THE VERY EYE OF NIGHT, that were stuck around when I was first in New York. If I can help it, that won't happen to me, not to any other artist I know.

And I <u>know</u> that Stan Brakhage (his correspondence with Willard Van Dyke is public record) and Shirley Clark did not go uncompensated for the use of their work by the Musuem. I don't know about Bruce Bailey, but I doubt, at the mildest, that he is wealthy enough to have travelled from the West Coast under his own steam, for any amount of love and honor (and nothing else). And, of course, if any of these three received <u>any</u> money at all (it is money that enables us to go on working, I repeat) then they received an <u>infinite</u> amount more than you are offering me. That puts us beyond the pale, even, of qualitative argument. It is simply an unimaginable cut in pay.

Item: that I do not live in New York City. Nor is it, strictly speaking, "convenient" for me to be there during the period you name. I'll be teaching in Buffalo every Thursday and Friday this coming Spring semester, so that I could hope to be at the Museum for a Saturday program. Are you suggesting that I drive down? The distance is well over four hundred miles, and March weather upstate is uncertain. Shall I fly, at my own expense, to face an audience that I know, from personal experience, to be, at best, largely unengaging, and at worst grossly provincial and rude?

Item: it is my understanding that filmmakers invited to appear on your "Cineprobe" programs currently receive an honorarium. How is it, then, that I am not accorded the same courtesy?

Very well. Having been prolix, I will now attempt succinctness. I offer you the following points for discussion:

1] It is my understanding, of old, that the Museum of Modern Art does not, as a matter of policy, pay rentals for films. I am richly aware that, if the museum paid us independent film artists, then it would be obliged also to pay rentals to the Hollywood studios. Since we all live in a fee-enterprise system, the Museum thus saves artists from the ethical error of engaging in unfair economic competition with the likes of Metro-Goldwyn-Mayer. (I invite anyone to examine, humanely, the logic of such a notion.) Nevertheless, I offer you the opportunity to pay me, at the rate of one-half my listed catalog rentals, for the several screenings you will probably subject my prints to. You can call the money anything you like: a grant, a charitable git, a bribe, or dividends on my common stock in Western Civilization . . . and I will humbly accept it. The precise amount in question is

$266.88, plus $54.– in cleaning charges, which I will owe the Film-Makers' Cooperative for their services when my prints are returned.

2] If I am to appear during the period you propose, then I must have roundtrip air fare, and ground transportation expenses, between Buffalo and Manhattan. I will undertake to cover whatever other expenses there may be. I think that amounts to about $90.–, subject to verification.

3] If I appear to discuss my work, I must have the same honorarium you would offer anyone doing a "Cineprobe". Correct me if I'm wrong, but I think that comes to $150.–.

4] Finally, I must request your earliest possible reply. I have only a limited number of prints available, some of which may already be committed for rentals screenings during the period you specify. Since I am committed in principle to this retrospective, delay might mean my having to purchase new prints specifically for the occasion; and I am determined to minimize, if possible, drains on funds that I need for making new work.

Please note carefully, Donald, that what I have written above is a list of requests. I do not speak of

demands which may only be made of those who are <u>forced</u> to negotiate.

But you must understand also that these requests are not open to bargaining: to bargain is to be humiliated. To bargain in this, of all matters, is to accept humiliation on behalf of others whose needs and uncertainties are greater even than mine.

You, of course, are <u>not</u> forced to negotiate. You are free. And since I am too, this question is open to discussion in matters of procedure, if not of substance.

I hope we can come to some agreement, and soon. I hope so out of love for my embattled art, and because I honor all those who pursue it. But if we cannot, then I must say, regretfully, however much I want it to take place, that there can be no retrospective showing of my work at the Museum of Modern Art.

Benedictions,

[Signed]
Hollis Frampton

LETTER 08
ART IS A GREAT INTELLECTUAL STIMULUS
Mary Cassatt to Theodate Pope
September 1903

Impressionist painter Mary Cassatt was born in 1844 in Allegheny City, Pennsylvania, and was one of seven children born to Robert and Katherine Cassatt. Aside from her studies at the Pennsylvania Academy of the Fine Arts, long periods of her life were spent in Europe. She eventually settled in France where she became friends with Edgar Degas and Camille Pissarro, and exhibited her work in Paris. She corresponded extensively with a variety of people throughout the years. In 1903 Cassatt wrote to her friend, Theodate Pope – one of the first women to become a professional architect – whose parents collected art.

THE LETTER

Dear Miss Pope,

I ought to have answered your letter before this,
but I have been very busy & I waited knowing you
would soon be again in this part of the world— I
had such a delightful letter from Miss Hillard &
quite counted on answering it in person in Paris. I
am very much disappointed to think I shall not see
her again, & that she will be so busy with the new
school she will not, probably, be able to come to
Europe very soon again—

You must not discourage her about Art, I am
sure she will derive great enjoyment from the
effects in her surroundings, & also for herself. I am
quite sure she will begin to feel pictures in a
different way, you must remember that art is a
great intellectual stimulus, & not reduce everything
to a decorative plane— What you say about
pictures being things alone, & standing for so
much, & therefore the wickedness of private indi-
viduals owning them, is I assure you a very false
way of seeing things, surely you would not have
museums crowded with undigested efforts of
everyone? Only in years after an artists [sic] death

33

are his pictures admitted to the Louvre, I wish to goodness we had some sensible rule of that kind at home, instead of that everything can be crowded into public Museums, & no standard is possible in such a mess. I think it is very exhilarating to a painter to know he touches some individual enough for that person to want to own his work, & surely there is nothing wrong in a hard working lawyer or business man putting some of his earnings in a work of art which appeals to him, when we must all work for the state may I no longer inhabit this planet— I assure you when I was in Boston & they took me to the Library & pointed with pride to all the young ones devouring books, & that without guidance, taking up all sorts of ideas of other people; I thought how much more stimulating a fine Museum would be, it would teach all those little boys who have to work for their living to admire good work, & give them the desire to be perfect in some one thing— I used to protest that all the wisdom of the World is not between the pages of books; & never did I meet any one in the Boston Museum, where the state the pictures are in is a disgrace to the Directors— As to the Havemeyer collection about which you feel so strongly, I consider they are doing a great work for the country in spending so much time & money in

bringing together such works of art, all the great public collections were formed by private individuals— You say "no collection can be interesting as a whole" — There again you are thinking of decoration, but I know two Frenchmen who are thinking of a journey to New York, *solely* to see the Havemeyer collection because *only there* can they see what they consider the finest modern pictures in contact with the finest old Masters, pictures which time has consecrated & only there can they study the influences which went to form the Modern School, or at least only there see the results— You see how others look on collections.

Enough of this we can talk of art when we meet, I do hope you will come down here I shall be so happy to see you, come on a Sunday evening—spend Tuesday or if the weather does not tempt you I will go up & see you; at any rate we must meet, I had a young couple today to see the place who were enchanted. Kindest regards to all the party & hope you are all well ever yours most cordially.

Mary Cassatt

LETTER 09
A LANDSCAPE PAINTER'S DAY IS
DELIGHTFUL

Jean-Baptiste-Camille Corot to an unknown recipient
1857

*Jean-Baptiste-Camille Corot, known to most as simply
Camille Corot, was born in 1796 to a wealthy Parisian
family. He showed no interest in art during his early
years, and it wasn't until he reached his mid-twenties
that Corot committed himself to the easel. In 1825,
having spent time studying under landscape painters in
France, he travelled to Italy to do the same. In the
years that followed he worked his way around Europe,
slowly building a reputation as one of the great land-
scapists. When he gleefully wrote this letter in 1857
and described his typical day, Corot was staying with a
group of artists at Château du Gruyères in Switzerland,
a castle atop a hill which at the time was owned by
the family of his friend, Daniel Bovy.*

THE LETTER

Gruyères, 1857

You know, a landscape painter's day is delightful.
You get up early, at three o'clock in the morning,
before sunrise; you go and sit under a tree; you
watch and wait. At first there is nothing much to
be seen. Nature looks like a whitish canvas with a
few broad outlines faintly sketched in; all is misty,
everything quivers in the cool dawn breeze. The sky
lights up. The sun has not yet burst through the
gauze veil that hides the meadow, the little valley,
the hills on the horizon. The nocturnal vapours are
still creeping in silvery flakes over the frozen green
of the grass. Ah! a first ray of sunshine! The tiny
flowers seem to wake up happily. Each has its
tremulous dewdrop. The leaves shiver with cold in
the morning breeze. Invisible birds are singing
beneath the leaves. It seems as though the flowers
were saying their prayers. Little butterfly-winged
cupids frolic over the meadow, making the tall
grass ripple. One sees nothing. Everything is there!
The whole landscape lies behind the transparent
gauze of the fog that now rises, reveals the
silver-spangled river, the fields, the trees, the
cottages, the further scene. At last one can discern
all that one could only guess at before.

The sun is up! There is a peasant at the end of the field, with his waggon drawn by a yoke of oxen. You can hear the little bell round the neck of the ram, the leader of the flock. Everything is bursting into life, sparkling in the full light – light which as yet is still soft and golden. The background, simple in line and harmonious in colour, melts into the infinite expanse of sky, through the bluish, misty atmosphere. The flowers raise their heads, the birds flutter hither and thither. A countryman on a white horse rides away down the steep-banked lane. The little rounded willows on the bank of the stream look like birds spreading their tails. It's adorable! and one paints! and paints!

AN ARTIST MUST POSSESS NATURE
Henri Matisse to Henry Clifford
14 February 1948

Henry Clifford worked as curator of the Philadelphia Museum of Art for more than twenty years, ending in 1965, and during his tenure won plaudits for organising exhibitions by the likes of Gustave Courbet, Vincent van Gogh and Pablo Picasso, to name just a few. In the spring of 1948, thanks in no small part to the efforts of Clifford, the museum became home to a retrospective of Henri Matisse, one of the twentieth century's most influential French artists. Before its opening, concerned that his work may be misinterpreted by aspiring young artists, Matisse wrote to Clifford from France and explained his worries. He later asked that the letter be reprinted in the show's catalogue. Clifford obliged.

THE LETTER

Venice, 14 February 1948

Dear Mr Clifford,

I hope that my exhibition may be worthy of all the work it is making for you, which touches me deeply.

However, in view of the great repercussions it may have, seeing how much preparation has gone into it, I wonder whether its scope will not have a more or less unfortunate influence on young painters. How are they going to interpret the impression of apparent facility that they will get from a rapid, or even a superficial, overall view of my paintings and drawings?

I have always tried to hide my own efforts and wished my works to have the lightness and joyousness of a springtime which never lets anyone suspect the labours it has cost. So I am afraid that the young, seeing in my work only the apparent facility and negligence in the drawing, will use this as an excuse for dispensing with certain efforts which I believe necessary.

The few exhibitions that I have had the opportunity of seeing during these last years make me fear that the young painters are avoiding the slow and

painful preparation which is necessary for the education of any contemporary painter who claims to construct by colour alone.

This slow and painful work is indispensable. Indeed, if gardens were not dug over at the proper time, they would soon be good for nothing. Do we not first have to clear, and then cultivate, the ground at each season of the year?

When an artist does not know how to prepare his flowering period, by work which bears little resemblance to the final result, he has a short future before him; or when an artist who has 'arrived' no longer feels the necessity of getting back to earth from time to time, he begins to go round in circles repeating himself, until by this very repetition, his curiosity is extinguished.

An artist must possess Nature. He must identify himself with her rhythm, by efforts that will prepare the mastery which will later enable him to express himself in his own language.

The future painter must feel what is useful for his development – drawing or even sculpture – everything that will let him become one with Nature, identify himself with her, by entering into the things – which is what I call Nature – that arouse his feelings. I believe study by means of drawing is most essential. If drawing is of the Spirit

and colour of the Senses, you must draw first, to cultivate the spirit and to be able to lead colour into spiritual paths. That is what I want to cry aloud, when I see the work of the young men for whom painting is no longer an adventure, and whose only goal is the impending first one-man show which will first start them on the road to fame.

It is only after years of preparation that the young artist should touch colour – not colour as description, that is, but as a means of intimate expression. Then he can hope that all the images, even all the symbols, which he uses, will be the reflection of his love for things, a reflection in which he can have confidence if he has been able to carry out his education, with purity, and without lying to himself. Then he will employ colour with discernment. He will place it in accordance with a natural design, unformulated and completely concealed, that will spring directly from his feelings; this is what allowed Toulouse-Lautrec, at the end of his life, to exclaim, 'At last, I do not know how to draw any more.'

The painter who is just beginning thinks that he paints from his heart. The artist who has completed his development also thinks that he paints from his heart. Only the latter is right, because his training

and discipline allow him to accept impulses that he can, at least partially, conceal.

I do not claim to teach; I only want my exhibition not to suggest false interpretations to those who have their own way to make. I should like people to know that they cannot approach colour as if coming into a barn door: that one must go through a severe preparation to be worthy of it. But first of all, it is clear that one must have a gift for colour as a singer must have a voice. Without this gift one can get nowhere, and not everyone can declare like Correggio, '*Anch'io son pittore.*' ['I too am a painter'.] A colourist makes his presence known even in a simple charcoal drawing.

My dear Mr Clifford, here is the end of my letter. I started it to let you know that I realize the trouble you are taking over me at the moment. I see that, obeying an interior necessity, I have made it an expression of what I feel about drawing, colour and the importance of discipline in the education of an artist. If you think that all these reflection of mine can be of any use to anyone, do whatever you think best with this letter . . .

Please believe me, dear Mr Clifford.

Yours gratefully,

Henri Matisse

LET ME HAVE ARTISTS FOR FRIENDS
J.D. Fergusson to Margaret Morris
19 October 1915

The Scottish Colourists were a group of four Scottish painters – Leslie Hunter, Samuel Peploe, Francis Cadell and J. D. Fergusson – who, on returning from France where they had trained for some time, introduced the vibrant colours of the French Fauvism movement to the art scene of their home country. It was in Paris in 1913 that one of the Colourists, J. D. Fergusson, met his future wife, the dancer Margaret Morris, and the next year they founded the Margaret Morris Club in Chelsea, a space in which like-minded painters, musicians and writers could gather. Fergusson's letters to Morris were as vivid as his canvases, and in October 1915 he wrote to her about a butcher whose passion for haggis was infectious.

THE LETTER

Dear Gosse . . . My God, let me have artists for friends—I mean people who feel, even if they're grocers, coal-heavers, anything you like except people devoid of sense of time, colour and sound.

The man I called on, on Sunday night, was discussing painting and has a real feeling for it. I mentioned Burns (of course) and he told me he was at a Golf Club dinner and a butcher who was a great admirer of Burns recited 'Address to a Haggis'. He put so much into it that he nearly collapsed at the end.

Being a squeamy veg, of course you'll think that most ludicrous and disgusting. I think it splendid and inspiring. The man making haggis, selling haggis and reciting the haggis address with real feeling of sympathy with Burns's understanding and sympathy, seems to me to be really getting near the real thing. I'm sorry you can't see it. Think of this disgusting person, a dealer in meat! Worse still, a dealer in tripes—that is, entrails, innards, or guts. A stuffer of tripes, entrails, innards or guts. A maker of haggises, or haggi. That is, a person who stuffs intestines of animals, with chopped livers, in

fact the large and small stomach-bags of sheep,
stuffing them with a mixture of lights, liver, heart
and oatmeal, Jamaica peppers and black peppers
and salt and the juice the pluck was boiled in,
stirred into a consistency and stuffed into the large
stomach-bag, sewn up with a needle and thread
and boiled for hours and prodded from time to
time with a large needle to let out the gas and
keep it from bursting.

Imagine him over a cauldron of boiling haggises,
watching them and prodding them with a needle,
moving them about rhythmically while Burns's
words run in his head and at moments of intense
emotion, at the *sight* of their fullness of form and
the *knowledge* of their fullness of food, of real food
that nourishes both through feeling and fact—at
these moments, feeling the continuity of idea that
comes from having conceived, created and
completed the work—at these moments this
frightful person will get into the fourth dimension,
so to speak, and recite with the fullness of emotion
derived from this comprehensive experience,
marking the rhythm with the needle, and punctu-
ating the time with prods.

The uncouth poem of the haggis-fed
ploughman, my dear Margaret, is enough to make
anyone brought up decently on Plato vomit. In fact

no one but Chaucer, or a butcher, or I could be expected to stand it. Don't tell any of your friends about this. Destroy this letter at once!

Yours JDF

LETTER 12

AN OBJECT OF PECULIAR ODIUM

Harriet Hosmer to *Art-Journal*

January 1864

*Born in Watertown, Massachusetts, in 1830, Harriet
Hosmer was a leading sculptor of the nineteenth
century who knew by the age of nineteen that she
would dedicate her life to becoming a master of her
chosen discipline. In 1862, after three years of toil, she
was ready to exhibit what was arguably her most
important work,* Zenobia in Chains *– a 7ft-high statue
of the legendary third-century Queen of Syria, carved
from marble. She sent it to London to be shown at the
International Exhibition, and over the course of a
month, thousands of visitors caught sight of Hosmer's
piece. Critics were united in their praise for this most
ambitious statue although some expressed doubts that
it could have been crafted by a woman. The next year,
an article appeared in* Art-Journal *in which it was
claimed that Zenobia 'was really executed by an Italian
workman in Rome'. Similar rumours appeared in other
publications. Furious, Hosmer responded to the initial
accusation with this letter to the journal's editor and
the threat of a lawsuit. Retractions and full apologies
soon arrived from all concerned.*

THE LETTER

Sir,—In the September number of the *Art-Journal*, an article entitled "Mr. Alfred Gatley," contains a statement so highly injurious to myself as an artist, that I cannot allow it to pass unnoticed.

I have been for a long time aware of the report that I employ a professional modeller to model my statues; and while this report was circulated through private mediums, I treated it with the contempt and silence which I felt it deserved; but not that it has assumed the form of a serious charge in public print, silence on my part would be equivalent to an admission of its truth, and I therefore place you in possession of facts, which I beg you to insert in your columns.

All artists are well aware, but the public may be ignorant, of the fact, that when a statue is to be made, a small model is first prepared by the artist, and that the professional modeller then enlarges that model, by scale, to any size the sculptor may require. This was the practice constantly pursued by Canova, and by Thorwaldsen, and is still continued by Mr. Gibson, by Tenerani, and by most of the sculptors of the present day. The charge now brought against me is, that this professional modeller does *all* my work, and to refute that

charge I here state, that after the statue of Zenobia was set up for me, from a small model, four feet high, which I had previously carefully studied, I worked with my own hands upon the full-sized clay model during a period of eight months, and therefore feel that if there is any merit in the figure, I may be entitled to at least a portion of it. Nor is this all; the man who undertook to prepare the work for me was not a professional modeller in clay, but one of the marble workmen in Mr. Gibson's studio.

For seven years I worked in Mr. Gibson's own studio, and I am authorised by him to state that during that time I had no more assistance in my work than every artist considers legitimate, nor, to use his own words, "would he have permitted me to send forth works from his studio which were not honestly my own."

We all know that few artists who have been in any degree successful enjoy the truly friendly regard of their professional brethren; but a *woman* artist, who has been honoured by frequent commissions, is an object of peculiar odium. I am not particularly popular with any of my brethren; but I may yet feel myself called upon to make public the name of one in whom these reports first originated, and who, sheltered under an apparent

personal friendship, has never lost an opportunity of defaming my artistic reputation. I remain, respectfully yours,

Harriet G. Hosmer.
[Countersigned] John Gibson.
Rome, November 14, 1863.

[We do not hesitate to insert Miss Hosmer's letter. The paragraph of which she complains was extracted from a contemporary. It formed part of an "extract," and its pernicious effect passed us unnoticed. We believe that statement to be entirely groundless, and manifestly unjust. It is not "our way" to inflict injury: more especially in the case of a woman who is working her way to fame. We know Miss Hosmer to stand high in this estimation of all artists —in Rome, in England, and in America; and that she is eminently entitled to the high position to which she has attained by industry and genius. Readily and gladly we make to her the best and most ample amends in our power. —Ed. A.-J.]

LETTER 13
GRAFFITI LOOKS LIKE SHIT
Michael Grady to Alicia McCarthy
8 April 1992

*Active throughout the 1990s, the posthumously named
and now fondly revered Mission School was one of San
Francisco's most significant and influential art scenes of
its era, a post-punk collective of young art students
from San Francisco Art Institute (SFAI) strongly influ-
enced by street culture and folk art. Indeed, that many
of its 'members' went on to become celebrated for
their work speaks to the movement's influence. But the
artists in question, and the art they produced, were
not always cherished by the local community, a fact
illustrated perfectly by this angry letter, sent to artist
Alicia McCarthy in 1992 by the Dean of Students at the
SFAI. The Dean, who misspells 'graffiti' throughout his
letter, was a man pushed to the edge by the very art
scene of which the institute would one day be so
proud. The work of Alicia McCarthy, incidentally, has
since been lauded and exhibited across the US.*

THE LETTER

San Francisco Art Institute
April 8, 1992.

Alicia McCarthy
c/o SFAI Student Mailboxes

Dear Alicia:
There has been a rash of grafitti at SFAI this
semester. Discrete inquiries as to the people
involved have led me to you. Although I have no
concrete evidence, your name keeps coming up. It
seems clear to me that you are in some way
involved in these occurrences.

Grafitti is a pain in the ass for everybody at SFAI.
I have been told that it's going to cost about
$2000, to clean up the latest rash. That's $2000
that could have gone to equipment, scholarships,
etc. At a time when the tuition is forced to go up
faster than anybody wants it to, we cannot tolerate
this kind of waste!

Why not just leave it? The short answer is that it
looks like shit. If those anonymous grafitti artists
delude themselves that this is art, they are
mistaken. Adolescent? self-indulgent? inconsiderate?

yes. Art? . . . no, at least not very interesting art – just mediocre attempts at appearing "subversive".

There's another important reason why the grafitti is especially harmful. As you may be aware we are attempting to buy the GAP building. In order to obtain the zoning variances required to turn it into studio space, the neighbors (who have to look at the grafitti) will be required to give their approval. Over the years, complaints from the neighbors about grafitti have been near the top of their list. This is <u>not</u> the time to antagonize them.

My initial tendency is to dismiss this sort of thing as mere childishness. In this case, though, I can't. It has been made very clear to me by Bill Barrett and the Board that this outbreak of grafitti has really angered everyone. I'm even getting complaints about it from the other students. So, if you, or anyone else is caught doing grafitti, it is quite possible that President Barrett will exercise his exclusive right to unilaterally dismiss the party involved from SFAI. At the very least I will be forced to take judiciary action. If you are one of those who are vandalizing SFAI, stop it. If you know of others who are involved in this activity, communicate this message to them. If you wish to

discuss the issue further, please meet with me in the Students Service Office. I appreciate your co-operation.

Sincerely,

[Signed 'Mike']

Michael Grady

Dean of Students

Richard Hamilton to Peter and Alison Smithson
16 January 1957

Born in Pimlico, London, in 1922 to a working-class family, Richard Hamilton's love affair with the world of art started early. At the age of ten he had taken up drawing; at twelve he was attending evening art classes meant for adults; at sixteen he was accepted into the Royal Academy. In the 1950s he was a leading light in the Independent Group (IG), a radical collective of British artists whose members created some of the earliest known examples of Pop Art. Much of their work was unveiled to the wider public by way of their groundbreaking This Is Tomorrow *exhibition in 1956, including Hamilton's iconic collage,* Just what is it that makes today's homes so different, so appealing?. *In January of the next year, as he pondered another show, Hamilton wrote a letter – which was un-answered – to architects and fellow IG members Peter and Alison Smithson, and set out a draft manifesto of sorts for the movement that would soon sweep the world.*

THE LETTER

16th January 1957

Dear Peter and Alison,

I have been thinking about our conversation of
the other evening and thought that it might be a
good idea to get something on paper, as much to
sort it out for myself as to put a point of view
to you.

There have been a number of manifestations in
the post-war years in London which I would select
as important and which have a bearing on what I
take to be an objective:

Parallel of Life and Art
(investigation into an imagery of general value)

Man, Machine and Motion
(investigation into a particular technological
imagery)
Reyner Banham's research on automobile styling
Ad image research (Paolozzi, Smithson, McHale)
Independent Group discussion on Pop Art–Fine Art
relationship

House of the Future

(conversion of Pop Art attitudes in industrial design to scale of domestic architecture)

This is Tomorrow

Group 2 presentation of Pop Art and perception material attempted impersonal treatment. Group 6 presentation of human needs in terms of a strong personal idiom.

Looking at this list it is clear that the Pop Art/ Technology background emerges as the important feature.

The disadvantage (as well as the great virtue) of the TIT show was its incoherence and obscurity of language.

My view is that another show should be as highly disciplined and unified in conception as this one was chaotic. Is it possible that the participants could relinquish their existing personal solutions and try to bring about some new formal conception complying with a strict, mutually agreed programme?

Suppose we were to start with the objective of providing a unique solution to the specific requirement of a domestic environment e.g. some kind of shelter, some kind of equipment, some kind of art.

This solution could then be formulated and rated on the basis of compliance with a table of characteristics of Pop Art.

Pop Art is:
Popular (designed for a mass audience)
Transient (short-term solution)
Expendable (easily-forgotten)
Low cost
Mass produced
Young (aimed at youth)
Witty
Sexy
Gimmicky
Glamorous
Big Business

This is just a beginning. Perhaps the first part of our task is the analysis of Pop Art and the production of a table. I find I am not yet sure about the "sincerity" of Pop Art. It is not a characteristic of all but it is of some – at least, a pseudo-sincerity is. Maybe we have to subdivide Pop Art into its various categories and decide into which category each of the subdivisions of our project fits. What do you think?

Yours

LETTER 15
DIVERSITY GUARANTEES OUR CULTURAL SURVIVAL

Martin Scorsese to the *New York Times*
19 November 1993

Few filmmakers have made more of an impression than Federico Fellini, the Italian maestro whose award-laden, four decade career peaked, in the eyes of most, with La Dolce Vita, his 1960 epic. After Fellini's death in October 1993, tens of thousands of mourners attended his memorial service at Cinecittà Studios. Around the same time, the New York Times published an article by lauded photographer Bruce Weber in which he made clear his impatience with the supposedly opaque, perplexing work of artists like Fellini, John Cage and Andy Warhol. He said of the latter two: 'I still hear noise and see a soup can.' Less than a fortnight after its publication, a reader responded to Weber's controversial, and controversially timed, piece, with a letter that was soon reprinted in the paper. It was written by another master of the craft: Martin Scorsese.

THE LETTER

New York,
19 Nov 1993

To the Editor:

"Excuse Me; I Must Have Missed Part of the Movie"
(The Week in Review, 7 November) cites Federico
Fellini as an example of a filmmaker whose style
gets in the way of his storytelling and whose films,
as a result, are not easily accessible to audiences.
Broadening that argument, it includes other artists:
Ingmar Bergman, James Joyce, Thomas Pynchon,
Bernardo Bertolucci, John Cage, Alain Resnais and
Andy Warhol.

It's not the opinion I find distressing, but the
underlying attitude toward artistic expression that is
different, difficult or demanding. Was it necessary
to publish this article only a few days after Fellini's
death? I feel it's a dangerous attitude, limiting,
intolerant. If this is the attitude toward Fellini, one
of the old masters, and the most accessible at that,
imagine what chance new foreign films and film-
makers have in this country.

It reminds me of a beer commercial that ran a
while back. The commercial opened with a black
and white parody of a foreign film – obviously a

combination of Fellini and Bergman. Two young men are watching it, puzzled, in a video store, while a female companion seems more interested. A title comes up: "Why do foreign films have to be so foreign?" The solution is to ignore the foreign film and rent an action-adventure tape, filled with explosions, much to the chagrin of the woman.

It seems the commercial equates "negative" associations between women and foreign films: weakness, complexity, tedium. I like action-adventure films too. I also like movies that tell a story, but is the American way the only way of telling stories?

The issue here is not "film theory," but cultural diversity and openness. Diversity guarantees our cultural survival. When the world is fragmenting into groups of intolerance, ignorance and hatred, film is a powerful tool to knowledge and under-standing. To our shame, your article was cited at length by the European press.

The attitude that I've been describing celebrates ignorance. It also unfortunately confirms the worst fears of European filmmakers.

Is this closed-mindedness something we want to pass along to future generations?

If you accept the answer in the commercial, why not take it to its natural progression:

Why don't they make movies like ours?
Why don't they tell stories as we do?
Why don't they dress as we do?
Why don't they eat as we do?
Why don't they talk as we do?
Why don't they think as we do?
Why don't they worship as we do?
Why don't they look like us?

Ultimately, who will decide who "we" are?
 —Martin Scorses

LETTER 16
IS THIS TOO MUCH TO ASK OF WHITE AMERICAN CHIVALRY?

Augusta Savage to the *New York World* newspaper
20 May 1923

*Born in Florida in 1892, Augusta Savage fought to
become a sculptor. As a young girl – the seventh of her
parents' fourteen children – she spent many an hour
quietly moulding small figurines from local clay, much to
the annoyance of her abusive father who, according to
Savage, 'almost whipped all the art out of me'. Instead
she found support and encouragement from her teachers,
and in 1919 she moved to New York to study and thrive
at the Cooper Union art school. In 1923 Savage applied
to take part in a women's art programme at the
Fontainebleau School of Fine Arts in France, and her
application was initially successful. However, her fellow-
ship was soon cancelled by the school's officials who,
having learned of her skin colour, believed her race
would be 'disagreeable to some white students'. A
campaign to reverse the cancellation, led by W. E. B. Du
Bois, was unsuccessful; this letter, from Savage to the
New York World newspaper, also had little impact. For
the rest of her career, Savage campaigned for the rights
of African-American artists, and in 1932 opened the
Savage Studio of Arts and Crafts in Harlem.*

THE LETTER

To the Editor of The World:

The recent flurry in your columns over the refusal of Mr. Peixotto's committee to let me go to France with other American artists because of the original mistake which I made in selecting a race to be born in that has done most of America's hard work has had some odd results, some of which have expressed themselves in my correspondence. I have received numerous letters from white people (many of them anonymous) bidding me not to try to force myself into the white race. The quality of courage and courtesy revealed by some of these unbidden exponents of "superiority," particularly by those who were evidently ashamed to sign their names, was not calculated to help one's faith in human nature. They seemed to have the notion that I must be a mulatto or octoroon, for that seems to me the only way in which I could possibly force myself into the white race. Now I happen to be unmistakable, and that way is obviously out of the question.

Isn't it rather odd that such people should always suppose that when a colored girl gets a chance to develop her natural powers it must be that she will want to become white? It gets to be a

tiresome task explaining to them that the desire to become better or more capable is a common quality of all human beings.

I hear so many complaints to the effect that Negroes do not take advantage of the educational opportunities offered them. Well, one of the reasons why more of my people do not go in for higher education is that as soon as one of us gets his head up above the crowd there are millions of feet ready and waiting to step on that head and crush it back again into the dead level of the commonplace, thus creating a racial deadline of culture in our Republic. For how am I to compete with other American artists if I am not to be given the same opportunity?

I haven't the slightest desire to force any question like that of "social equality" upon any one. Instead of desiring to force my society upon ninety-nine white girls, I should be pleased to go over to France on a ship with a black Captain, a black crew and myself as sole passenger, if on my arrival there I would be given the same opportunities for study as the other ninety-nine girls; and I feel sure that my race would not need to be ashamed of me after the final examinations.

We are sneered at for not being the social and intellectual equals, after sixty years of Western civi-

lization, of people with thousands of years of this same civilization; yet when we set out to try to lessen the distance between us we are treated as if the attempt were a crime. Why not give us the chance to try? Are some white people really afraid that we might succeed? Give us but fifty years more with an even break and you may find no further cause for complaint. We are not asking for "social equality" with white people in the manner generally supposed; we have enough "society" for our own needs. But we do want—and we have a right to seek—the chance to prove that we are men and women with powers and possibilities similar to those of other men and women. After "the bond-man's two hundred and fifty years of unrequited toil" is this too much to ask of white American chivalry?

AUGUSTA SAVAGE
New York, May 17.

LETTER 17
ART IS AN ADVENTURE INTO AN
UNKNOWN WORLD
Mark Rothko and Adolph Gottlieb to the *New York Times*
7 June 1943

*In 1913, having spent the first decade of his life in
what is now Latvia, Mark Rothko emigrated to the US
with his family to begin a new life. Another decade
later, after a short stint at Yale University, he fell in
love with the world of art and enrolled at the prestig-
ious Art Students League of New York. There he was
taught by noted Cubist painter Max Weber, after
which he met lifelong friend and fellow abstract
expressionist painter Adolph Gottlieb. It wasn't until
the late 1940s that Rothko settled into the style for
which he is now known: large rectangles of soft-edged
colour arranged on huge canvases. By the time of his
death in 1970, Rothko had produced more than 800
works on canvas, and in 2014 his 1951 oil painting* No.
6 (Violet, Green and Red) *sold for a record-breaking
€140 million. Many others have sold for millions.
Critics, however, were often less enthused. In 1943,
reporting on the* Third Annual Exhibition of Modern
Painters and Sculptors *in New York,* New York Times *art
critic Edward Allen Jewell wrote:*

You will have to make of Marcus Rothko's 'The Syrian Bull' what you can; nor is this department prepared to shed the slightest enlightenment when it comes to Adolph Gottlieb's 'Rape of Persephone'.

Rothko and Gottlieb responded jointly, by letter.

THE LETTER

June 7, 1943

Mr. Edward Alden Jewell
Art Editor, New York Times
229 West 43 Street
New York, N. Y.

Dear Mr. Jewell:

To the artist, the workings of the critical mind is one of life's mysteries. That is why, we suppose, the artist's complaint that he is misunderstood, especially by the critic, has become a noisy commonplace. It is therefore, an event when the worm turns and the critic of the TIMES quietly yet publicly confesses his "befuddlement", that he is "non-plussed" before our pictures at the Federation Show. We salute this honest, we might say cordial reaction towards our "obscure" paintings, for in other critical quarters we seem to have created a bedlam of hysteria. And we appreciate the gracious opportunity that is being offered us to present our views.

We do not intend to defend our pictures. They make their own defense. We consider them clear

statements. Your failure to dismiss or disparage them is prima facie evidence that they carry some communicative power.

We refuse to defend them not because we cannot. It is an easy matter to explain to the befuddled that "The Rape of Persephone" is a poetic expression of the essence of the myth; the presentation of the concept of seed and its earth with all its brutal implications; the impact of elemental truth. Would you have us present this abstract concept with all its complicated feelings by means of a boy and girl lightly tripping?

It is just as easy to explain "The Syrian Bull", as a new interpretation of an archaic image, involving unprecedented distortions. Since art is timeless, the significant rendition of a symbol, no matter how archaic, has as full validity today as the archaic symbol had then. Or is the one 3000 years old truer?

But these easy program notes can help only the simple-minded. No possible set of notes can explain our paintings. Their explanation must come out of a consummated experience between picture and onlooker. The appreciation of art is a true marriage of minds. And in art, as in marriage, lack of consummation is ground for annulment.

The point at issue, it seems to us, is not an

"explanation" of the paintings but whether the intrinsic ideas carried within the frames of these pictures have significance.

We feel that our pictures demonstrate our aesthetic beliefs, some of which we, therefore, list:

1. To us art is an adventure into an unknown world, which can be explored only by those willing to take the risks.
2. This world of the imagination is fancy-free and violently opposed to common sense.
3. It is our functions as artists to make the spectator see the world our way – not his way.
4. We favor the simple expression of the complex thought. We are for the large shape because it has the impact of the unequivocal. We wish to reassert the picture plane. We are for flat forms because they destroy illusion and reveal truth.
5. It is a widely accepted notion among painters that it does not matter what one paints as long as it is well painted. This is the essence of academicism. There is no such thing as good painting about nothing. We assert that the subject is crucial and only that subject matter is valid which is tragic and timeless. That is why we profess spiritual kinship with primitive and archaic art.

Consequently if our work embodies these beliefs, it must insult anyone who is spiritually attuned to interior decoration; pictures for the home; pictures for over the mantle; pictures of the American scene; social pictures; purity in art; prize-winning potboilers; the National Academy, the Whitney Academy, the Corn Belt Academy; buckeyes, trite tripe; etc.

Sincerely yours,
[Signed]
Adolph Gottlieb
Marcus Rothko

130 State Street
Brooklyn, New York

THE MOST SPECTACULAR MONOCHROME
REALIZATIONS

Yves Klein to the President of the International
Conference for the Detection of Nuclear Explosions
1958

*When he wasn't travelling the world practising judo,
French conceptual artist Yves Klein could often be
found creating artworks that involved his other passion
in life: the colour blue. Or, to be more precise,
International Klein Blue, the hue he created and
patented in 1960. Klein was born in the South of
France in 1928, and in 1948 composed a piece of music
named 'Monotone-Silence Symphony' that consisted of
a single note, and silence. Two years later, he moved
from monotone to monochrome, and began to paint
the single colour pieces for which he is now revered. In
1958 he wrote a letter to the President of the
International Conference for the Detection of Nuclear
Explosions with a suggestion, which is reproduced
below. Four years later, Klein suffered a fatal heart
attack. He was thirty-four.*

THE LETTER

Honorable President,
Distinguished Delegates,
I take upon myself in complete humility, but also in full conscience of an artist, to present a proposition to the board of directors of your Conference with regard to atomic and thermonuclear explosions. This proposition is quite simple: to paint A and H bombs blue in such a manner that their eventual explosions should not be recognized by only those who have vested interests in concealing their existence or (which amounts to the same thing) revealing it for purely political purposes but by all who have the greatest interest in being the first to be informed of this type of disturbance, which I deem to say is all of my contemporaries. All I need is the position and the number of A-bombs and H-bombs and a remuneration, to be discussed, that ought, in any case, to cover:

– The price of colorants.
– My own artistic contribution (I will be responsible for the coloring – in blue – of all future nuclear explosions).

It is quite clear that we shall exclude cobalt blue as being notoriously radioactive and that we shall use only Klein Blue which has earned me the celebrity of which you are undoubtedly aware.

Although I am fully occupied with my current work, notable with creating the ambiance [*sic*] of the great Gelsenkirchen Opera House, the humanitarian aspect of my proposal seems to me to have priority over any other considerations. Do not think, however, that I am among those who place art after matter. Quite to the contrary, its disintegration allows for the most spectacular monochrome realizations that humanity, and I dare say, the cosmos itself will have known.

In this double effect, I remain, distinguished sirs, your very devoted,

K.

P.S. It is clear that not only the explosions but also the *fall-outs* ought to be inalterably tinted in blue by my IKB procedure.

cc: His Holiness the Dalai Lama; His Holiness the Pope Pius XII; President of the League of the Rights of Man; Director of the International Committee of Peace; Secretary General of the United Nations; Secretary General of UNESCO; President of the

International Federation of Judo; Editor-in-Chief of
the *Christian Science Monitor*; Bertrand Russell;
Dr. Albert Schweitzer.

LETTER 19
IF IT IS NOT THOUGHT OUT, IT IS NOTHING
Oscar Wilde to Marie Prescott
March–April 1883

On 20 August 1883, a play based loosely on the life of Russian revolutionary Vera Zasulich made its debut at the Union Square Theater in New York, with a lead performance by Kentucky-born actress Marie Prescott and a script written by Irish playwright Oscar Wilde – the first of his plays to be performed. Sadly for all involved, Vera; Or, the Nihilists *failed to win Broadway over, and it was yanked from the stage after just one week following intensely negative reviews from critics and audience members alike. Wilde promptly returned home. All of which makes this letter from Wilde to Prescott more interesting, written months before* Vera *debuted and then, a week before the curtains went up, partially and tactically reprinted in the* New York Herald.

THE LETTER

My dear Miss Prescott,

I have received the American papers and thank you for sending them. I think we must remember that no amount of advertising will make a bad play succeed, if it is not a good play well acted. I mean that one might patrol the streets of New York with a procession of vermilion caravans twice a day for six months to announce that Vera was a great play, but if on the first night of its production the play was not a strong play, well acted, well mounted, all the advertisements in the world would avail nothing. My name signed to a play will excite some interest in London and America. Your name as the heroine carries great weight with it. What we want to do is to have all the real conditions of success in our hands. Success is a science; if you have the conditions, you get the result. Art is the mathematical result of the emotional desire for beauty. If it is not thought out, it is nothing.

As regards dialogue, you can produce tragic effects by introducing comedy. A laugh in an audience does not destroy terror, but, by relieving it, aids it. Never be afraid that by raising a laugh you destroy tragedy. On the contrary, you intensify it. The canons of each art depend on what they appeal

to. Painting appeals to the eye, and is founded on the science of optics. Music appeals to the ear and is founded on the science of acoustics. The drama appeals to human nature, and must have as its ultimate basis the science of psychology and physiology. Now, one of the facts of physiology is the desire of any very intensified emotion to be relieved by some emotion that is its opposite. Nature's example of dramatic effect is the laughter of hysteria or the tears of joy. So I cannot cut out my comedy lines. Besides, the essence of good dialogue is interruption. All good dialogue should give the effect of its being made by the reaction of the personages on one another. It should never seem to be ready made by the author, and interruptions have not only their artistic effect but their physical value. They give the actors time to breathe and get new breath power.

I remain, dear Miss Prescott, your sincere friend
OSCAR WILDE

'SUCCESS IS SCIENCE;
IF YOU HAVE THE
CONDITIONS, YOU GET
THE RESULT.'

– *Oscar Wilde*

DEAR EDITOR

Adrian Piper to various editors

1 January 2003

Born in New York in 1948, Adrian Piper is a conceptual artist and philosopher whose achievements, both academic and professional, are impressive by anyone's standards. At the age of twenty, while studying at the School of Visual Arts, she began to exhibit her artwork around the world. After graduating, she hopped over to the City College of New York to earn a B.A. in Philosophy, then entered Harvard for her Ph.D. All told, her formal education lasted twenty-seven years, after which she began to spread her wings professionally. She has won numerous awards for her work, including in 2015 the Golden Lion Award for Best Artist at the 56th Venice Biennale, and her artwork can be found in the Museum of Modern Art, the Metropolitan Museum of Art and others. She has also authored multiple philosophical texts for which she has been awarded numerous fellowships. In 2003, with all of this in mind, Piper wrote an open letter to all editors.

THE LETTER

Dear Editor:

Please don't call me a black artist.
Please don't call me a black philosopher.
Please don't call me an African American artist.
Please don't call me an African American philosopher.

Please don't call me a woman artist.
Please don't call me a woman philosopher.
Please don't call me a female artist.
Please don't call me a female philosopher.

Please don't call me a black woman artist.
Please don't call me a black woman philosopher.
Please don't call me an African American woman
 artist.
Please don't call me an African American woman
 philosopher.
Please don't call me a black female artist.
Please don't call me a black female philosopher.
Please don't call me an African American female
 artist.
Please don't call me an African American female
 philosopher.
Please don't call me a female black artist.

Please don't call me a female black philosopher.
Please don't call me a female African American
artist.
Please don't call me a female African American
philosopher.

Please don't call me an artist who happens to be
black.
Please don't call me a philosopher who happens to
be black.
Please don't call me an artist who happens to be
African American.
Please don't call me a philosopher who happens to
be African American.

Please don't call me an artist who happens to be a
woman.
Please don't call me a philosopher who happens to
be a woman.
Please don't call me an artist who happens to be
female.
Please don't call me a philosopher who happens to
be female.

Please don't call me an artist who happens to be
black and a woman.

Please don't call me a philosopher who happens to
be black and a woman.

Please don't call me an artist who happens to be a
woman and black.

Please don't call me a philosopher who happens to
be a woman and black.

Please don't call me an artist who happens to be
African American and a woman.

Please don't call me a philosopher who happens to
be African American and a woman.

Please don't call me an artist who happens to be a
woman and African American.

Please don't call me a philosopher who happens to
be a woman and African American.

Please don't call me an artist who happens to be
black and female.

Please don't call me a philosopher who happens to
be black and female.

Please don't call me an artist who happens to be
female and black.

Please don't call me a philosopher who happens to
be female and black.

Please don't call me an artist who happens to be
African American and female.

Please don't call me a philosopher who happens to
be African American and female.

Please don't call me an artist who happens to be
 female and African American.
Please don't call me a philosopher who happens to
 be female and African American.

Please don't call me a black artist and philosopher.
Please don't call me a black philosopher and artist.
Please don't call me an African American artist and
 philosopher.
Please don't call me an African American philoso-
 pher and artist.

Please don't call me a woman artist and philoso-
 pher.
Please don't call me a woman philosopher and
 artist.
Please don't call me a female artist and philoso-
 pher.
Please don't call me a female philosopher and
 artist.

Please don't call me a black woman artist and
 philosopher.
Please don't call me a black woman philosopher
 and artist.
Please don't call me an African American woman
 artist and philosopher.

Please don't call me an African American woman
 philosopher and artist.
Please don't call me a black female artist and
 philosopher.
Please don't call me a black female philosopher and
 artist.
Please don't call me an African American female
 artist and philosopher.
Please don't call me an African American female
 philosopher and artist.
Please don't call me a female black artist and
 philosopher.
Please don't call me a female black philosopher and
 artist.
Please don't call me a female African American
 artist and philosopher.
Please don't call me a female African American
 philosopher and artist.

Please don't call me an artist and philosopher who
 happens to be black.
Please don't call me a philosopher and artist who
 happens to be black.
Please don't call me an artist and philosopher who
 happens to be African American.
Please don't call me a philosopher and artist who
 happens to be African American.

Please don't call me an artist and philosopher who
 happens to be a woman.
Please don't call me a philosopher and artist who
 happens to be a woman.
Please don't call me an artist and philosopher who
 happens to be female.
Please don't call me a philosopher and artist who
 happens to be female.

Please don't call me an artist and philosopher who
 happens to be black and a woman.
Please don't call me a philosopher and artist who
 happens to be black and a woman.
Please don't call me an artist and philosopher who
 happens to be a woman and black.
Please don't call me a philosopher and artist who
 happens to be a woman and black.
Please don't call me an artist and philosopher who
 happens to be African American and a woman.
Please don't call me a philosopher and artist who
 happens to be African American and a woman.
Please don't call me an artist and philosopher who
 happens to be a woman and African American.
Please don't call me a philosopher and artist who
 happens to be a woman and African American.
Please don't call me an artist and philosopher who
 happens to be black and female.

Please don't call me a philosopher and artist who
 happens to be black and female.
Please don't call me an artist and philosopher who
 happens to be female and black.
Please don't call me a philosopher and artist who
 happens to be female and black.
Please don't call me an artist and philosopher
 who happens to be African American and
 female.
Please don't call me a philosopher and artist who
 happens to be African American and female.
Please don't call me an artist and philosopher who
 happens to be female and African American.
Please don't call me a philosopher and artist who
 happens to be female and African American.

Dear Editor,
I hope you will bring to my attention any permut-
ations I have overlooked.

I write to inform you that
I have earned the right to be called an artist.
I have earned the right to be called a philosopher.
I have earned the right to be called an artist and
 philosopher.
I have earned the right to be called a philosopher
 and artist.

I have earned the right to call myself anything I
 like.

Thank you in advance for your consideration.
Adrian Piper
 1 January 2003

LETTER 21
PAINTING AND SCULPTURE ARE ONE AND THE SAME THING
Michelangelo to Benedetto Varchi
1549

In 1543 Italian humanist and poet Benedetto Varchi wrote to a number of celebrated artists and asked for their opinion of paragone – a long-running and some-times heated discussion between sculptors and painters of the Italian Renaissance in which the supposed super-iority of their artistic disciplines was hotly debated. In this particular instance, eight replies arrived, most of which were predictable in their allegiance. One, however, was written by an artist who just so happened to be a master of both sculpture and painting: one Michelangelo di Lodovico Buonarroti Simoni – otherwise known simply as Michelangelo.

THE LETTER

Messer Benedetto,

So that it may be clear that I have received your little book, as indeed I have, I will make some reply to what you ask me, though I write ignorantly. I say that painting appears to me to be the better, the more it tends towards relief, and that relief work appears to me to be the worse, the more it tends towards painting. It had ever seemed to me that sculpture was the lantern of painting, and that the difference between the two was as great as between sun and moon.

But now that I have read your little book, wherein you say that, philosophically speaking, those things that have the same end are one and the same thing, I have altered my opinion; and I say that if greater judgment and difficulty, impediment and fatigue, do not give greater nobility, then painting and sculpture are one and the same thing; and so that it may be thought thus, no painter should feel less esteem for sculpture than painting; and likewise, no sculptor less for painting than for sculpture. By sculpture, I mean that which is made by taking away [from the block]; that which is made by adding, resembles painting. Let that suffice; for since both, painting and sculpture,

proceed from the same understanding, we should make peace between them, that such disputes be abandoned – for they take up more time than is needed for the work itself.

As for him who wrote that painting was more noble than sculpture, if he had no better understanding of whatever else he wrote, my servant-girl would have written it better. One might say an infinity of things, never yet said, regarding such matters; but as I say, it would take too much time, and I have little time, for I am not only an old man, but almost numbered with the dead: so I pray you to hold me excused. I commend myself to you and thank you heartily for the too great honour you do me, and which does not beseem me.

Your Michelagniolo Buonarroti, in Rome

THE POINT OF BEING AN ARTIST IS THAT YOU MAY LIVE

Sherwood Anderson to John Anderson

April 1927

American writer Sherwood Anderson began his life in Camden, Ohio, in 1873, and spent much of his early years taking on manual labour jobs until a brief career in advertising was cut short by a nervous breakdown. Eventually he was able to sustain himself and his family doing what he loved most – writing – and he is now best known for his influential 1919 collection of stories, Winesburg, Ohio, *and his 1925 novel,* Dark Laughter. *In December 1926 Anderson, his wife Elizabeth and his two children, John and Mimi, boarded the United States Lines SS* President Roosevelt *in New York and sailed to Europe for a long stay, and to drop the children off in France where they were to attend school. In April, shortly after Anderson arrived home, he wrote a letter of advice to his son, who was now studying painting in Paris.*

THE LETTER

Ripshin Farm
Grant, Virginia

Dear John,
Something I should have said in my letter yesterday.

In relation to painting.

Don't be carried off your feet by anything
because it is modern − the latest thing.

Go to the Louvre often and spend a good deal
of time before the Rembrandts, the Delacroixs.

Learn to draw. Try to make your hand so uncon-
sciously adept that it will put down what you feel
without your having to think of your hands.

Then you can think of the thing before you.

Draw things that have some meaning to you. An
apple, what does it mean?

The object drawn doesn't matter so much. It's
what you feel about it, what it means to you.

A masterpiece could be made of a dish of turnips.

Draw, draw hundreds of drawings.

Try to remain humble. Smartness kills everything.

The object of art is not to make salable pictures.
It is to save yourself.

Any clearness I have in my own life is due to
my feeling for words.

The fools who write articles about me think that one morning I suddenly decided to write and began to produce masterpieces.

There is no special trick about writing or painting either. I wrote constantly for fifteen years before I produced anything with any solidity to it.

For days, weeks, and months now I can't do it.

You saw me in Paris this winter. I was in a dead blank time. You have to live through such times all your life.

The thing, of course, is to make yourself alive. Most people remain all of their lives in a stupor.

The point of being an artist is that you may live.

Such things as you suggested in your letter the other day. I said "Don't do what you would be ashamed to tell me about."

I was wrong.

You can't depend on me. Don't do what you would be ashamed of before a sheet of white paper – or a canvas.

The materials have to take the place of God.

About color. Be careful. Go to nature all you can. Instead of paint shops – other men's palettes – look at the sides of buildings in every light. Learn to observe little things – a red apple lying on a grey cloth.

Trees – trees against hills – everything. I know

little enough. It seems to me that if I wanted to learn about color I would try always to make a separation. There is a plowed field here before me, below it is a meadow, half decayed cornstalks in the meadow making yellow lines, stumps, sometimes like looking into an ink bottle, sometimes almost blue.

The same in nature is a composition.

You look at it thinking – what made up that color. I have walked over a piece of ground, after seeing it from a distance – trying to see what made the color I saw.

Light makes so much difference.

You won't arrive. It is an endless search.

I write as though you were a man. Well, you must know my heart is set on you.

It isn't your success I want. There is a possibility of your having a decent attitude toward people and work. That alone may make a man of you.

S.A.

LETTER 23
WHAT LIMBS THAT MAN COULD DRAW!
Paula Modersohn-Becker to Carl Woldemar Becker
27 February 1897

*German painter Paula Modersohn-Becker was only
thirty-one when she died as a result of complications
during childbirth. However, despite her all-too-early
death, she left behind an impressive body of work that
included over 500 paintings and even more drawings.
All of which cemented her reputation as one of the
most significant artists of the Expressionist movement
that had originated in her home country. Her corres-
pondence was also extensive. This letter was written in
1897, months after she had enrolled at the highly
respected art school run by the Verein der Berliner
Künstlerinnen (Association of Berlin Women Artists),
with the full blessing of her supportive parents. Her
enthusiasm at her new surroundings is palpable.*

THE LETTER

Dear Father, after a morning of hard work it is such a pleasure to sit down and thank you for that beautiful box of pastels. I keep looking at the rows of magnificent crayons and can hardly wait to begin using them.

My model right now is a little Hungarian boy, a mousetrapper, who cannot understand a single word of German, so that is it impossible to scold him when he comes every morning half an hour late. But it is such fun drawing him.

Last Thursday after class I went to see the Kupferstichkabinett [Print Room] for the first time. I had stood at the glass entrance several times before, but the solemn gloom behind it always frightened me away. Yesterday I took heart and went in, feeling like an intruder in the sanctum sanctorum. An attendant came up to me and silently handed me a slip of paper on which I had to write down what I wanted to look at; "Michelangelo, drawings by" . . . He brought me a gigantic folio. I could hardly wait to look inside. At the same time, being the only woman in the midst of this overpowering masculinity, I would have given anything to make myself invisible. But as soon as I opened the folio and could study Michelangelo's powerful

draftsmanship, I could forget the whole rest of the world. What limbs that man could draw!

We had the most amazing model that evening in life-drawing class. At first, the way he stood there, I was shocked at how ugly and thin he seemed. But as soon as he began to pose and when he tensed all his muscles so that they rippled down his back, I became very excited. How strange and wonderful, my dears, that I can react this way! That I am able to live totally in my art! It is so wonderful. Now if I can only turn this into something good. But I won't even think about that now – it just makes me uneasy.

Let me tell you something funny that happened to me. Do you remember, Mother, the drawing of the nude woman with the beautiful black hair which you took back to Bremen? Well, I drew her [again] in Fräulein Bauck's class. She was wearing a black dress with a white collar, and so was I; only the style of her dress was a good deal more chic. And she struck out a beautifully shod foot so smartly that I felt obliged to modestly hide my rather clumsy feet. And later when this young lady with her gentle dove's eyes appeared for a second time, it turned out that in place of her black mane her hair was now a beautiful chestnut brown. She told us some sort of story about washing her hair and having gotten hold of the wrong bottle. But I thought to myself quietly, Oh, yes, *c'est la vie!*

'HOW STRANGE AND
WONDERFUL, MY
DEARS, THAT I CAN
REACT THIS WAY! THAT I
AM ABLE TO LIVE
TOTALLY IN MY ART!'
— Paula Modersohn-Becker

LETTER 24
SPECIFICALLY, A DUEL
Mark Pauline to Dennis Oppenheim
10 December 1982

Born in 1953, artist and inventor Mark Pauline is the founder of Survival Research Laboratories, an 'industrial performance art' group who, since forming in 1978, have been organising large-scale, carefully choreographed shows in which massive machines and mechanised sculptures interact. In the early 1980s Pauline became aware of similarly mechanical installations being shown by fellow performance artist Dennis Oppenheim. This letter was his response.

THE LETTER

December 10, 1982

Dear Dennis Oppenheim,

As the originator and most active proponent of the
concept of mechanical performance, I have, for
some time now, been aware of your feeble and
uninspired attempts to employ instruments of force.
Initially this information seemed a fluke, merely
indicating another instance of an older New York
artist struggling to get back to where the money
was. Consequently it was of no real concern to
myself or to my assistants at SRL. Increasingly,
however, we have found ourselves in the undesir-
able position of being compared to you. Add to
this our disgust at the exaggerated publicity gener-
ated by your insignificant mechanical events.
Furthermore, there have been suggestions from
acquaintances of mine in NYC that any similarities
between our activities might be due to more than
mere coincidence. After considering several possible
options, I have concluded that this affront to the
honor of my organization can be settled only
through a direct confrontation. Specifically, a duel,
to be staged with machines of our choice, at a
public location determined by yourself in or

around NYC; to be judged by a panel of seven individuals acceptable to us both; to take place before the end of August 1983. If after a reasonable length of time no response to this letter is forthcoming, we at SRL will rest assured that your activities are indeed a gutless sham, propped up by clever publicity schemes and financed by a wealthy, bored social elite.

Sincerely yours
Mark Pauline,
Director, SRL

LETTER 25
I AM NO LONGER AN ARTIST
Paul Nash to Margaret Nash
13 November 1917

In London in 1915, as he recovered from an injury received while serving on the Western Front, English artist Eric Kennington began painting The Kensingtons at Laventie, *a now iconic depiction in oils of his own infantry platoon standing amidst the debris of conflict. It was later exhibited, and its resulting success led to the British Government's implementation of a scheme in which British artists were actively commissioned to report on the war through art. One of the first of those official war artists was Paul Nash, a surrealist painter who specialised in landscapes. In November 1917, stationed in Belgium at the Battle of Passchendaele and feeling utterly disillusioned, amidst scenes so hellish that he was unable to commit them to a canvas of any kind, Nash attempted to put his experience into words in a letter home to his wife, Margaret.*

THE LETTER

My beloved,

I hope you got my letter. I am settled here for a
week so very soon expect letters will come through
to me as I have wired GHQ my address . . .

I have just returned, last night, from a visit to
Brigade Headquarters up the line and I shall not
forget it as long as I live. I have seen the most
frightful nightmare of a country more conceived by
Dante or Poe – unspeakable, utterly indescribable.
In the fifteen drawings I made I may give you
some vague idea of its horror but only being in it
and of it can ever make you sensible of its dreadful
nature and of what our men in France have to face.
We all have a vague notion of the terrors of a
battle, and can conjure up with the aid of some of
the more inspired war correspondents and the
pictures in the Daily Mirror some vision of a battle-
field; but no pen or drawing can convey this
country – the normal setting of the battles taking
place day and night, month after month. Evil and
the incarnate fiend alone can be master of the cere-
monies in this war; no glimmer of God's hand is
seen. Sunset and sunrise are blasphemous mockeries
to man; only the black rain out of the bruised and

swollen clouds or this, the bitter black of night, is fit atmosphere in such a land. The rain drives on; the stinking mud becomes more evilly yellow, the shell holes fill up with green-white water, the roads and tracks are covered in inches of slime, the black dying trees ooze and sweat and the shells never cease. They whine and plunge overhead, tearing away the rotting tree stumps, breaking the plank roads, striking down horses and mules; annihilating, maiming, maddening; they plunge into the grave, and cast up on it the poor dead. It is unspeakable, godless, hopeless. I am no longer an artist interested and curious, I am a messenger who will bring back word from the men who are fighting to those who want the war to last for ever. Feeble, inarticulate, will be my message, but it will have a bitter truth, and may it burn their lousy souls.

No letters at all yet. I wish they would send them over . . . In a day or two I will have more to say & not so gloomy. I am longing to hear all about my darling. For a little time adieu my sweet little baby, with a long long kiss the kind only we can give.

from your most loving, idolatrous lover,
Paul

LETTER 26
AN EXPLOSIVE SLAB OF CHOCOLATE
Lord Victor Rothschild to Laurence Fish
4 May 1943

Born in London in 1919, Laurence Fish was a highly respected commercial illustrator known throughout the industry for his impeccable graphic design and technical drawing skills. During his long and distinguished career he attracted commissions from many of the UK's largest companies, including British Rail, Dunlop, Shell and BP, designed countless magazine covers and award-winning posters, and saw his work exhibited at such institutions as the Royal Academy and the Royal Institute of Painters. Surely his greatest commission, however, arrived by letter in May 1943, at the height of World War II. It was sent to him by Lord Victor Rothschild – then head of MI5's counter-sabotage unit – in response to a novel and ultimately fruitless Nazi plot to assassinate Winston Churchill.

THE LETTER

BOX No. 500,
PARLIAMENT STREET B.O.,
LONDON, S.W.1.

SF.54/7/57/B.1.C.

4th May 1943

Dear Fish,

I wonder if you could do a drawing for me of an explosive slab of chocolate. We have received information that the enemy are using pound slabs of chocolate which are made of steel with a very thin covering of real chocolate. Inside there is high explosive and some form of delay mechanism, but we do not know what, so it could not be put in the drawing. When you break off a piece of chocolate at one end in the normal way, instead of it falling away, a piece of canvas is revealed stuck into the middle of the piece which has been broken off and sticking into the middle of the remainder of the slab. When the piece of chocolate is pulled sharply, the canvas is also pulled and this initiates the mechanism. I enclose a very poor sketch done

by somebody who has seen one of these. It is wrapped in the usual sort of black paper with gold lettering, the variety being PETERS. Would it be possible for you to do a drawing of this, one possibly with the paper half taken off revealing one end and another with the piece broken off showing the canvas. The text should indicate that this piece together with the attached canvas is pulled out sharply and that after a delay of seven seconds the bomb goes off.

Please return the enclosed drawing.

Yours sincerely,

Lord Rothschild

'I WONDER IF YOU
COULD DO A DRAWING
FOR ME OF AN
EXPLOSIVE SLAB OF
CHOCOLATE.'

— Lord Rothschild

LETTER 27
TO HELL WITH THE EXHIBITION
Frida Kahlo to Nickolas Muray
16 February 1939

In January 1939, with war looming, iconic Mexican painter Frida Kahlo visited France for the first time. She had been invited by writer and founding Surrealist André Breton, who in 1938, beguiled by her artwork, had organised her successful first show in New York and was now keen to do the same in Paris. On arrival, however, Kahlo discovered the extent of Breton's disorganisation: most pressingly, that her paintings were trapped in customs and Breton had no gallery in which to exhibit them. With help from Marcel Duchamp, Mexique eventually did open at the city's Galerie Renou et Colle, her work shown amongst the photography of Manuel Álvarez Bravo and what she considered to be 'junk'. Then, shortly before the show was to open, Kahlo contracted a kidney infection. It was in hospital that she wrote this letter to her lover, the photographer Nickolas Muray, and let off some steam.

After the exhibition, Kahlo fled France and returned home to Mexico, but not before selling one of her self-portraits, The Frame, to the Louvre – the first painting from a twentieth-century Mexican artist ever to be bought by this most illustrious of museums.

THE LETTER

My adorable Nick. Mi Niño,
I am writing you on my bed in the American
Hospital. Yesterday it was the first day I didn't have
fever and they aloud me to eat a little, so I feel
better. Two weeks ago I was so ill that they brought
me here in an ambulance because I couldn't even
walk. You know that I don't know why or how I
got coli-bacilus on the kidneys thru the intestines,
and I had such an inflamation and pain that I
thought I was going to die. They took several Xrays
of the kidneys and it seems that they are infected
with those damn colibacilus. Now I am better and
next Monday I will be out of this rotten hospital. I
can't go to the hotel, because I would be all alone,
so the wife of Marcel Duchamp invited me to stay
with her for a week while I recover a little. Your
telegram arrived this morning and I cried very
much – of happiness, and because I miss you with
all my heart and my blood. Your letter, my sweet,
came yesterday, it is so beautiful, so tender, that I
have no words to tell you what a joy it gave me. I
adore you my love, believe me, like I never loved
anyone – only Diego will be in my heart as close

as you – always. I haven't tell Diego a word about
all this trouble of being ill – because he will worry
so much – and I think in few days I will be allright
again, so it isn't worthwhile to alarm him.

Don't you think so?

Besides this damn sickness I had the lousiest
luck since I arrived. In first place the question of
the exibition is all a damn mess. Until I came the
paintings were still in the custum house, because
the s. of a b. Breton didn't take the trouble to get
them out. The photographs which you sent ages
ago, he never received – so he says – the gallery
was not arranged for the exibit at all and Breton
has no gallery of his own long ago. So I had to
wait days and days just like an idiot till I met
Marcel Duchamp (a marvelous painter) who is the
only one who has his feet on the earth, among all
this bunch of coocoo lunatic son of bitches of the
surrealists. He immediately got my paintings out
and tried to find a gallery. Finally there was a
gallery called "Pierre Colle" which accepted the
damn exibition. Now, Breton wants to exibit
together with my paintings, 14 portraits of the XIX
century (Mexicans) about 32 photographs of
Alvarez Bravo, and lots of popular objects which he
bought on the markets of Mexico – all this junk,
can you beat that? For the 15th of March the

gallery supose to be ready. But . . . The 14 oils of
the XIX Century must be <u>restored</u> and the damn
restoration takes a whole month. I had to lend to
Breton 200 bucks (Dlls) for the restoration because
he doesn't have a penny. (I sent a cable to Diego
telling him the situation and telling that I lended to
Breton that money – he was furious, but now is
<u>done</u> and I have nothing to do about it) I still have
money to stay here till the beginning of March so I
don't have to worry so much.

Well, after things were more or less settled as I
told you, few days ago Breton told me that the
associated of Pierre Colle, an old bastard and son of
a bitch, saw my paintings and found that only <u>two</u>
were possible to be shown, because the rest are too
"<u>shocking</u>" for the public!! I could of kill that guy
and eat it afterwards, but I am so sick and tired of
the <u>whole affair</u> that I have decided to send every
thing to hell, and scram from this rotten Paris
before I get nuts myself. You have no idea the kind
of bitches these people are. They make me vomit.
They are so damn "intelectual" and rotten that I
can't stand them any more. It is realy too much for
my character – I rather sit on the floor in the
market of Toluca and sell tortillas, than to have any
thing to do with those "Artistic" bitches of Paris.
They sit for hours on the "cafés" warming their

precious behinds, and talk without stopping about "culture" "art" "revolution" and so on and so forth, thinking themselves the gods of the world, dreaming the most fantastic nonsenses, and poisoning the air with theories and theories that never come true. Next morning, they don't have any thing to eat in their houses because <u>none of them work</u> and they live as parasites of the bunch of rich bitches who admire their "genius" of "Artists". <u>Shit</u> and only <u>shit</u> is what they are. I never seen Diego or you, wasting their time on stupid gossip and "intelectual" discussions. That is why you are real <u>men</u> and not lousy "artists" – Gee weez! It was worthwhile to come here only to see why Europe is rottening, why all this people – good for nothing – are the cause of all the Hitlers and Mussolinis. I bet you my life I will hate this place and its people as long as I live. There is something so false and unreal about them that they drive me nuts. I am just hoping to get well soon and scram from here.

My ticket will last for a long time but I already have acommodations for the "Isle de France" on the 8 of March. I hope I can take this boat. In any case I won't stay here longer than the 15th of March. To hell with the exibition in London. To hell with everything concerning Breton and all this

lousy place. I want to go back <u>to you</u>. I miss every movement of your being, your voice, your eyes, your hands, your beautiful mouth, your laugh so clear and honest. <u>YOU</u>. I love you my Nick. I am so happy to think I love you – to think you wait for me – you love me.

My darling give many kisses to Mam on my name, I never forget her. Kiss also Aria and Lea. For you, my heart full of tenderness and caresses. One special kiss on your neck. Your give my love to Mary Skear if you see her and to Ruzzy.

Xochite.

LETTER 28
I AM NOT MAURITS TO HIM
Mick Jagger and M.C. Escher
January 1969

*M.C. Escher was an enigmatic Dutch artist born in
1898 to George Escher, a civil engineer, and Sara
Gleichman. Until the mid-1930s, living in Rome with his
wife, Jetta Umiker, Escher was an avid painter of the
landscapes and scenes of nature that surrounded him.
It wasn't until approximately 1935, triggered by the
sight of some geometric tiling at Alhambra Palace in
Spain, that he began to produce the mind-boggling
work for which he is now celebrated: optical illusions
that he called 'mental imagery'. In January 1969,
months before seventy-one-year-old Escher produced
the last of his prints (Snakes), he was contacted by the
Rolling Stones frontman, Mick Jagger, who had a
request related to their upcoming album,* Through The
Past Darkly (Big Hits Vol. 2). *Escher soon replied.*

THE LETTERS

Dear Maurits,

For quite some time now I have had in my possession your book (Graphic Works Of . . .) and it never ceases to amaze me each time I study it! In fact I think your work is quite incredible and it would make me very happy for a lot more people to see and know and understand exactly what you are doing.

In March or April this year, we have scheduled our next LP record for release, and I am most eager to reproduce one of your works on the cover-sleeve. Would you please consider either designing a "picture" for it, or have you any unpublished works which you might think suitable – the "optical illusion" idea very much appeals to me, although one like "Evolution" would of course be equally as suitable – and would say the same thing. You might even like to do a long one like "Metamorphosis" which we could then reproduce as a folding-out sleeve. It could be either in one colour or full colour, that would be up to you entirely.

Naturally, both you and your publishers would get full credits on the sleeve, and we could negotiate a fee on hearing of your decision to do it. I would be most grateful if you could contact Peter Swales or Miss Jo Bergman at the above address or telephone (reverse

charge), and either will give you every necessary assistance. However, I am not so fortunate as to possess a Dutch interpreter, and so if you do not speak English or French, I would again be grateful if you could fix up somebody in Baarn to oblige.

Yours very sincerely,
MICK JAGGER
for ROLLING STONES LTD.

Escher's reply to Mr Peter Swales:

January 20

Dear Sir,
Some days ago I received a letter from Mr. Jagger asking me to design a picture or to place at his disposal unpublished work to reproduce on the cover-sleeve for an LP record.

My answer to both questions must be no, as I want to devote all my time and attention to the many commitments I made; I cannot possibly accept any further assignments or spend any time on publicity.

By the way, please tell Mr. Jagger I am not Maurits to him, but

Very sincerely,
M.C. Escher.

LETTER 29
I AM APPALLED BY MOCA'S DECISION
Hans Haacke to Richard Koshalek
1995

In 1995, prior to the opening of an exhibition at Los Angeles' Museum of Contemporary Art, named 1965–1975: Reconsidering the Object of Art, its fifty-five featured artists were surprised and dismayed to learn that the show, and by extension their artwork, was being sponsored by the tobacco company, Philip Morris. Reactions were varied; most, though, were fuelled by anger. German artist Hans Haacke led the pack with this letter to the museum's director, Richard Koshalek. A copy was then hung beneath Haacke's work, accompanied by the complaints of the show's other members. Adrian Piper withdrew her exhibits altogether, asking that they be replaced by photographs of her parents, both of whom had died as a result of their smoking habits – a suggestion that Koshalek declined.

THE LETTER

October 10th, 1995

Dear Mr. Koshalek:

From the invitation to this week's opening of the MOCA exhibition 1965–1975: *Reconsidering the Object of Art* I learned, with dismay, that the celebration of the re-opened Temporary Contemporary and, as it appears (the wording is not quite clear), the exhibition itself, is sponsored by Philip Morris Companies Inc.

When you asked me to lend my work (*Shapolsky et al. Manhattan Real Estate Holdings, a Real-Time Social System, as of May 1, 1971*) to this exhibition, you did not mention the sponsorship of the show – and unfortunately I failed to inquire.

Let me explain why I am appalled by MOCA's decision to have Philip Morris sponsor this event.

As Dr. Louis Sullivan, the former U.S. Secretary of Health and Human Services, bluntly stated in 1990: "Cigarettes are the only legal product that, when used as intended, cause death." Government agencies estimate that more than 300,000 Americans die every year from smoking related diseases, and that smoking costs the nation $52 million annually in health expenses or time lost from work.

Recently, California Congressman Henry A. Waxman, basing his assertion on internal company documents and scientific analysis, accused Philip Morris of deliberately manipulating nicotine levels in cigarettes, in effect thus also manipulating their addictive quality. The U.S. Food and Drug Administration concluded that nicotine was a drug that should be regulated.

In addition to sponsoring art events for public relations purposes, Philip Morris also sponsors Senator Jesse Helms. Not only did the company regularly contribute to the Senator's reelection campaigns, it also made substantial contributions to the Jesse Helms Center in North Carolina, where the Senator's version of "American values" is promoted.

As you know, Senator Helms is determined to destroy the National Endowment for the Arts, an agency that has supported your museum, this exhibition, and many of the invited artists. The irony is inescapable and bitter.

The Senator is notorious for his hostility to the freedom of expression and sexual orientation, not to speak of the many other positions he holds which are anathema to probably all artists in the exhibition. When Philip Morris's promotion of Senator Helms became known in 1990, ACT-UP

called for an international boycott of the company's products. Many artists joined the boycott.

You must also be aware that, last year, Philip Morris threatened to withhold its sponsorship of cultural events in New York if the City Council passed a ban on smoking in public places. Your peers in New York museums were solicited to become tobacco industry lobbyists. The boldness of this instrumentalization of culture by a corporation was unprecedented.

The artists represented in *1965–1975: Reconsidering the Object of Art* belong to a generation that, as you wrote in your letter to me, "began to question the nature, meaning and function of art and thus marked a significant rupture with traditional forms and concepts of artmaking." You also said this "will, quite auspiciously, be the re-opening exhibition" for MOCA's Temporary Contemporary.

Particularly in light of these statements, respect for the artists and their work, as well as the interests and ethics of an institution such as yours, should have precluded MOCA from allowing Philip Morris the privilege of being associated with this event.

Sincerely yours,
Hans Haacke

LETTER 30
DO
Sol LeWitt to Eva Hesse
14 April 1965

In 1960 pioneering American artists Sol LeWitt and Eva
Hesse met for the first time and instantly clicked,
quickly forming a strong, deep bond that would last
for ten years and result in countless inspirational
discussions and rich exchanges of ideas. Indeed, they
remained incredibly close friends until May 1970, at
which point Hesse, still only thirty-four years of age,
sadly passed away after being diagnosed with a brain
tumour. In 1965, halfway through their relationship,
Eva found herself facing a creative block during a
period of self-doubt, and told Sol of her frustrating
predicament. A few weeks later, Sol replied with the
work of art seen here – a wonderful, invaluable letter
of advice, copies of which have since inspired artists
the world over, and which now grace the walls of art
studios in all corners of the globe.

THE LETTER

Dear Eva,

April 14

It will be almost a month since you wrote to me
and you have possibly forgotten your state of mind
(I doubt it though). You seem the same as always,
and being you, hate every minute of it. Don't!
Learn to say "Fuck You" to the world once in a
while. You have every right to. Just stop thinking,
worrying, looking over your shoulder, wondering,
doubting, fearing, hurting, hoping for some easy
way out, struggling, grasping, confusing, itching,
scratching, mumbling, bumbling, grumbling,
humbling, stumbling, numbling, rambling,
gambling, tumbling, scumbling, scrambling,
hitching, hatching, bitching, moaning, groaning,
honing, boning, horse-shitting, hair-splitting,
nit-picking, piss-trickling, nose sticking,
ass-gouging, eyeball-poking, finger-pointing,
alleyway-sneaking, long waiting, small stepping,
evil-eyeing, back-scratching, searching, perching,
besmirching, grinding, grinding, grinding away at
yourself. Stop it and just
 D O
 From your description, and from what I know

of your previous work and your ability; the work you are doing sounds very good "Drawing – clean – clear but crazy like machines, larger and bolder . . . real nonsense." That sounds fine, wonderful – real nonsense. Do more. More nonsensical, more crazy, more machines, more breasts, penises, cunts, whatever – make them abound with nonsense. Try and tickle something inside you, your "weird humor." You belong in the most secret part of you. Don't worry about cool, make your own uncool. Make your own, your own world. If you fear, make it work for you – draw & paint your fear & anxiety. And stop worrying about big, deep things such as "to decide on a purpose and way of life, a consistant approach to even some impossible end or even an imagined end." You must practice being stupid, dumb, unthinking, empty. Then you will be able to

DO

I have much confidence in you and even though you are tormenting yourself, the work you do is very good. Try to do some BAD work – the worst you can think of and see what happens but mainly relax and let everything go to hell – you are not responsible for the world – you are only respon-sible for your work – so DO IT. And don't think that your work has to conform to any preconceived

form, idea or flavor. It can be anything you want it to be. But if life would be easier for you if you stopped working – then stop. Don't punish yourself. However, I think that it is so deeply engrained in you that it would be easier to

DO

It seems I do understand your attitude somewhat, anyway, because I go through a similar process every so often. I have an "Agonizing Reappraisal" of my work and change everything as much as possible – and hate everything I've done, and try to do something entirely different and better. Maybe that kind of process is necessary to me, pushing me on and on. The feeling that I can do better than that shit I just did. Maybe you need your agony to accomplish what you do. And maybe it goads you on to do better. But it is very painful I know. It would be better if you had the confidence just to do the stuff and not even think about it. Can't you leave the "world" and "ART" alone and also quit fondling your ego. I know that you (or anyone) can only work so much and the rest of the time you are left with your thoughts. But when you work or before your work you have to empty your mind and concentrate on what you are doing. After you do something it is done and that's that. After a while you can see some are better than

others but also you can see what direction you are going. I'm sure you know all that. You also must know that you don't have to justify your work – not even to yourself. Well, you know I admire your work greatly and can't understand why you are so bothered by it. But you can see the next ones & I can't. You also must believe in your ability. I think you do. So try the most outrageous things you can – shock yourself. You have at your power the ability to do anything.

I would like to see your work and will have to be content to wait until Aug or Sept. I have seen photos of some of Tom's new things at Lucy's. They are very impressive – especially the ones with the more rigorous form; the simpler ones. I guess he'll send some more later on. Let me know how the shows are going and that kind of stuff.

My work has changed since you left and it is much better. I will be having a show May 4–29 at the Daniels Gallery 17 E 64th St (where Emmerich was), I wish you could be there. Much love to you both.

Sol

PERMISSION CREDITS

Every effort has been made to trace copyright holders and obtain their permission for the use of copyright material. The publisher apologises for any errors or omissions and would be grateful if notified of any corrections that should be incorporated in future reprints or editions of this book.

ACKNOWLEDGEMENTS

It requires a dedicated team of incredibly patient people to bring the *Letters of Note* books to life, and this page serves as a heartfelt thank you to every single one of them, beginning with my wife, Karina – not just for kickstarting my obsession with letters all those years ago, but for working with me as Permissions Editor, a vital and complex role. Special mention, also, to my excellent editor at Canongate Books, Hannah Knowles, who has somehow managed to stay focused despite the problems I have continued to throw her way.

Equally sincere thanks to all of the following: the one and only Jamie Byng, whose vision and enthusiasm for this series has proven invaluable; all at Canongate Books, including but not limited to Rafi Romaya, Kate Gibb, Vicki Rutherford and Leila Cruickshank; my dear family at Letters Live: Jamie, Adam Ackland, Benedict Cumberbatch, Aimie Sullivan, Amelia Richards and Nick Allott; my agent, Caroline Michel, and everyone else at Peters, Fraser & Dunlop; the many illustrators who have worked on the beautiful covers in this series; the talented performers who have lent their stunning voices not just to Letters Live, but also to the *Letters of Note* audiobooks; Patti Pirooz; every single archivist and librarian in the world; everyone at Unbound; the team at the Wylie Agency for their assistance and understanding; my foreign publishers for their continued support; and, crucially, my family, for putting up with me during this process.

Finally, and most importantly, thank you to all of the letter writers whose words feature in these books.